ROOSTERS

Photographs © Philippe Schlienger

© Assouline 2005
Assouline Publishing
601 West 26th Street, New York, NY 10001 U.S.A.
Tel: +1 212 989 6810 Fax: +1 212 647 0005
www.assouline.com

Translated from the French by Marjolijn de Jager

ISBN: 2 84323 741 6

Color separation: Gravor (Switzerland)
Printed and bound by Grafiche Milani (Italy)

PHILIPPE SCHLIENGER

ROOSTERS

Introduction by Jean-Baptiste Harang

ASSOULINE

To you, who are not born yet.

Like Sisyphus, I wore myself out vainly pulling weeds that had invaded the garden. It was a gift, on that particular day, that Pierre was helping me out. Together, new accomplices in the effort, we were talking about everything and nothing, of Perche and nature, rain and fine weather, and we were getting to know each other.

"It's so far down to the ground," he said as he stood up, a rough hand in the small of his back. "Actually, I have a favor to ask of you; perhaps you didn't know this, but I collect roosters. That's what I like to do, breed chickens and roosters!"

"Really? How many do you have?"

"Almost fifty. They can be troublesome, it's true, because their crowing bothers other people. I was thinking of going to the agricultural fair to show my fowl, children love them. Since you are a photographer, I was wondering if you might take their portraits and then with the help of the photographs I could make an explanatory board with some anecdotes and the name of each breed. What do you think?"

I couldn't see myself photographing Gallinaceans at all, no thanks! Besides, I had more work than I could handle and the few moments of calm I did have were those I spent in the garden.

"You know, animals are not my specialty at all… stuffed perhaps, if I must…"

Silence.

How could I refuse Pierre anything, with his disarming kindness and his irresistible longing to communicate his passion.

"All right, we could do it next week if you want," I heard myself respond to him.

"That's fine! I'll bring them over next Sunday."

"But not all fifty of them, right?"

"Don't worry! See you Sunday."

The following Sunday his car pulled up in my courtyard with such cacophony that the sound of the motor was almost muffled by it. I had completely forgotten about the appointment and didn't immediately understand what was going on. It was only when Pierre proudly opened his trunk, revealing a dozen wooden cages each of which held a strange animal, that I blanched from a rush of adrenaline. There I was, my breath taken away, facing the uncouth guests who were so noisily interrupting my life.

"Let's get to work," he exclaimed enthusiastically.

My first reaction was to go into a state of denial: "No, it isn't possible, I'm not going to photograph those animals! I have a reputation to uphold, and besides I'm much more comfortable with still life, hard-boiled eggs, and roast chicken…with inanimate objects, in short, than with live roosters. It's impossible! Out of the question…"

I had to rationalize this hilarious situation. Fine, I'm going to do it quickly, on the gravel in the courtyard, against the brick wall, in the shade of the willow tree; that should be more than sufficient to satisfy dear Pierre; he is very sweet, but really…"

When, with much ado and a fluttering of wings, Pierre managed to extricate the first specimen of his collection, I saw a bird such as I'd never seen before. With the array of his feathers fanned out wide, an arrogant crest, and an accusing eye, the magnificent Renato, dean of the farmyard, stared straight at me and seemed to be saying:

"You, my friend, had better not make a distorted portrait of this."

I took the threat quite seriously and invited Pierre to come along with me to the studio, having decided to give it my best.

I had taken the portrait of a prominent painter for a luxury magazine a few days before against a white backdrop. The lighting was still set up. All I needed to do was add a table and trestles instead of the stool, and to ask Pierre to position his rooster, Renato.

I lit my lamps, grabbed my camera, and framed the rooster's head. That's when the miracle occurred, that strange feeling of excitement one sometimes has when shooting: everything's in place, the moment is right, the light is perfect.

I leaned over to the viewfinder.

Looking straight in the eye of a rooster is a terrifying experience. You probe the entire depth of past ages, as if a prehistoric being in all its ferocity were suddenly surfacing after an interminable journey through time. I pressed the shutter release, my blood like ice. I had just crossed the gaze of another epoch. I knew I had taken a strong image, not the portrait of a rooster, but the portrait of a rooster that was scrutinizing me and putting me on guard. What mysterious message was locked inside that penetrating stare?

Pierre began to whisper in Renato's ear, gently, patiently, and quite naturally. For him, conversing with his friend was the most normal thing in the world. Moreover, the animal seemed to understand everything and was reacting to his admirer's words by turning his head and raising his beak. His violent look was replaced by pride. Renato felt he was the most beautiful, the most dominating and, in his own way, he let that be known. Forcefully flapping his wings twice, he made several lights go off, a strident cockadoodledoo caused us to lose our hearing for a few seconds and unleashed a concert of unimaginable echoes from the challengers who were still in the car, not to mention the rest of the smelly provocations and other demonstrations of strength.

Like a fashion magazine editor who whispers in the ear of a top model to put her at ease, Pierre stoically continued to lavish his soothing counsel on the bird. I never did know what mad promises he must have made to his roosters for them to be so cooperative, but one thing is certain: it worked. Renato, just like the others, offered me his most handsome profile.

I never chose to photograph roosters, it was they who chose me, and for this reason I thank them for it.

<div style="text-align: right;">

Philippe Schlienger
May 2005

</div>

AND GOD CREATED THE ROOSTER

There is no denying that God created the world. We even know that he did so in less than a week and that on the seventh day it was all sewn up. It has all been recounted in a large book that we respect and call a Bible. Various more or less apocryphal versions of this magnificent work are in circulation, some of which have become the foundations of disputed religions, the true one of which enlightens us. Let us summarize:

In the beginning God created heaven and earth, and that was a good foundation. To get a clearer view, God said: "Let there be light and there was light." At that time God ruled over the elements with an iron hand. "And the evening and the morning were the first day." At night, he rested.

On the second day he created the water, sea, rivers, and other liquid forms, and brought order among them. On the third day he made his garden, greenery, trees, and fruits. The next day, which was the fourth, he created the moon, the sun, and all kinds of other stars, because two days earlier he had divided light and darkness and at night you couldn't see a thing. Now we have reached the fifth day, which is the one we are interested in, and it is high time because tomorrow God is leaving for the Weekend, God knows where.

God said, and I quote: "Let the earth bring forth the living creature after his kind, cattle, and the creeping thing, and beast of the earth after his kind." God saw that it was good. Then God said: "Let us make the rooster in our image, after our likeness, and let him have dominion over the fish of the sea, and over the fowl of the air, and over the cattle, and over all the earth, and over every creeping thing that creepeth upon the earth." God created the rooster in his own image, rooster and hen created he them.

So it is that the rooster resembles God. In any event, in this particular bible it is an indisputable fact. Moreover, we know that God abandoned any number of rough drafts of creation, which he crumpled up into little balls and threw into

space without worrying about the consequences. Usually, he'd stumble over the choice of animal he had presumably made in his image, and to whom he'd offer complete domination over the brand new world. They say that these first attempts, certainly superior and skillful approximations, live their life among the stars or, like bubbles, burst in oblivion, even in the creator's. They say that one of the most successful attempts consisted of a world dominated by a mammal, presumably created in the image of God as well, an omnivorous and viviparous biped, who stands erect and eats apples. He possessed a smug intelligence, was rough and uncontrolled, and, thinking himself clever and therefore capable of inventing infernal machines, caused these to blow up in his face before new generations could be born.

That's how God learned to mistrust intelligence and thus, as we know, he created the rooster in his image and offered him the world. It should be said that the rooster was not expecting this. It should also be mentioned that this creation of the world, known as "Roosters' World," resolves one of the silliest philosophical questions ever asked: which came first, the chicken or the egg? Neither one nor the other, it was the rooster. And certainly not in the shape of an egg, since both a chicken and a rooster hatch from an egg and what God wants is a rooster. Therefore, short of believing that God resembles an egg and that he created the egg in his image—of course not—, all eggs resemble each other, while roosters do not, and we know that the rooster created by God to resemble him was a full-fledged rooster, a rooster of a divine and canonic age. When we refer to the other attempts at creating the world (see above) it has to do with an adult every time, and not an egg, an embryo, or even a plan that God placed at the center of the earth. God doesn't create according to a plan, he improvizes, and his early sketches are works of art that he either crumples up or finishes. God is an artist and doesn't do anything with premeditation. We even know how God went about it.

Let's go back to the Book: "And the Lord God formed the rooster of the dust of the ground, and breathed into his nostrils the breath of life; and the rooster became a living soul. He covered the animal's nostrils with a beak so that life wouldn't be taken away from him too soon. And the Lord God planted a garden eastward in Eden and there he put the rooster he had formed, the tree of life in the midst of the garden, and the tree of knowledge of good and evil. And the Lord God commanded the rooster, saying: Of every tree of the garden thou mayest freely eat; but of the tree of the knowledge of good and evil, thou shalt not eat of it; for in the day that thou eatest thereof thou shalt surely die." The Lord God said: "It is not good

that the rooster should be alone; I will make him a help meet." And the Lord God caused a deep sleep to fall upon the rooster and he slept (supposedly, to get his rooster to fall asleep, God must have gone about it the way you or I would, he placed the rooster's head beneath one of his wings and rocked him as long as necessary; as soon as he closes his eyes, a rooster thinks it is night). "He took one of his ribs and closed up the flesh instead thereof." From this rib, God shaped a chicken and brought it to the rooster, who said: "This is now bone of my bones and flesh of my flesh!"

Let's read the rest: "The rooster and the chicken were both naked and were not ashamed. Now the serpent was more subtle than any beast of the field which the Lord God had made. He said to the chicken: 'Hath God said, Ye shall not eat of every tree of the garden?' And the chicken said unto the serpent: 'We may eat of the fruit of the trees of the garden. But of the fruit of the tree which is in the midst of the garden, God hath said: "Ye shall not eat of it, neither shall ye touch it, lest ye die."' And the serpent said unto the chicken: 'Ye shall not surely die, for God doth know that in the day ye eat thereof, then your eyes shall be opened, and ye shall be as gods, knowing good and evil.' The chicken saw that the tree was good for food, and that it was pleasant to the eyes, and a tree to be desired to make one wise." But her rooster of a husband didn't understand a thing and already well provided with intelligence (he had enough of it, at least, or so he thought, to be able to make judgments), he jumped upon the serpent and consumed him in one mouthful. The malicious counselor was swallowed and God's plans—although for a long time it was thought he didn't make any—fell apart. God flung some tar and feathers at his rooster and chicken and didn't see them again.

Having gulped the traitor down, neither the rooster nor the chicken had any further access to intelligence, which their offspring still prove today. God had missed his chance and he could only blame himself, for by having created the trap, had he not created the ruffian himself? As we know, God had invented everything. A sore loser, he took it out on the serpent: "Because thou hast done this, thou art cursed above all cattle, and above every beast of the field: upon thy belly shalt thou go, and dust shalt thou eat all the days of thy life."

And then the Lord God saw that the only thing he could do was start all over again. The world, in which he had tried to make the rooster in his own image, he crumpled up into a large ball, aimed it at the waste basket, missed, and began to work again. He focused on a new idea, a universe made of hardwood, dominated by a figure in his image whom he gave the name of basketball player.

THE PLANET OF THE ROOSTERS

Having been abandoned by the almighty God, the roosters did their best to resemble him, but the model grew ever more distant, and they were left to their own devices without any hope of ever changing the situation. It is not because of his crest that the rooster is a cretin, no, it is because he ate the serpent instead of biting into the apple. Since that time, he makes do with earthworms, fallen grain, while fruit hangs too high for his inflexible wings.

But let's get back to the story: God's rough drafts aren't lost on everybody, there's always someone who manages to save some of it, even just a little bit. He picks up the crumpled ball, straightens it out by flattening it on his thigh with the palm of his hand, and there you have it: the work, a rickety world, starts up again in wobbly fashion, a tiny planet that turns like a spud at first, then finds its minuscule star-equilibrium in an abandoned galaxy. The planet of the roosters, whose existence is known only to a few experts with nothing to do, is called Gallia, under the pretext that it is the Gallinaceae who are in dispute over its rule. Invisible to the naked eye, it was discovered toward the end of the nineteenth century by an amateur Greek astronomer named Dimitri Kodossis, who liked nothing better than to rummage around in the disorder of the universe. In France, Gallia is better known as "Little Helen," in retaliation, because Gallia means France in Greek and the rooster is its emblem. That is nothing to brag about (foreigners, especially the Belgians, claim that the French didn't steal him since it is supposedly the only animal who sings with both feet in the shit; in fact, the rooster appeared on the French flags during the Revolution as a replacement for the fleur de lys, using the pretext that in Latin "coq gaulois" is "gallus gallus," which always causes laughter). Kodossis ended up blind in one eye because he was always looking through his telescope. His claims were neither denied nor confirmed by the invention of the electronic telescope.

In fact, roosters are very different from us. They're covered with feathers and, if we'd let them, they'd fly off. Indeed, following the example of people, they stand

upright on their hind legs. The rooster isn't reputed to be intelligent but, like people, he thinks he is. The most notable differences can be seen with one's own eyes: the rooster has small crests, wattles like mumps, ear pieces, spurs, and a plastron. He only sees these as advantageous when a human complains of having the mumps. The rooster has no hair but all kinds of quills, sickles, lancets, and remiges. The man of the quill is merely a fantasy. The examination of a rooster's skeleton is deceptive; it is a question of scale but, one on one, it reminds us more of the human skeleton than of that of the fish, which is what we were when our earth was wholly covered with water. Certainly, he has no teeth, but then people's teeth often end up by being false. And when the skeleton has been properly cleaned, one would be hard pressed to tell the bones of a wing apart from those of an arm. A few caudal vertebrae help to make the feathers of his tail stand up, something humans cannot claim.

Man and rooster have two practices in common—albeit it unequally—that ought to bring them closer together: on the one hand, the rooster is polygamous just as man is at times; on the other hand, even if man and rooster are normally whole, it could be said that the capon is to the rooster what the eunuch is to man—a fatty body. If every rooster that plays a role in this work turns out to be polygamous, then not a single one of them has been turned into a capon, since these two states are contradictory both among men and among roosters, but to each his own.

Comparing men and roosters may seem ludicrous, but once you know what is known about the uncommon birds presented to you, you will understand that both species have similar personalities, both good and bad. From a distance, and based on these generalities, one might think that all roosters resemble each other, a bit like those idiots who claim that the Chinese, seen through western eyes, are all the same as if seen from another planet. The Chinese, like roosters, differ from one another to such an extent that each of them has a name of his own and they are identified by being made to have a Photomat picture taken, an anthropometric photograph, that is, which is attached—when needed—to passports or exhibited in police stations. Looking at the ones below, they don't look alike, they look like us, badly finished, badly coiffed, with claws, coquettish or slovenly, with a murderous or benevolent look, ornery or sleepy, modest or wearing his medals, stentorian or hoarse, crested or tipsy, black or white, haughty or shabby, superb or ugly, innocent or murderous, some will go to paradise and others must pass through the High Court. Or through the courtyard of the farm.

Jean-Baptiste Harang

The rooster is a beanpole that scratches.
The rooster thinks he is something else
and easily stands on top of his ego.

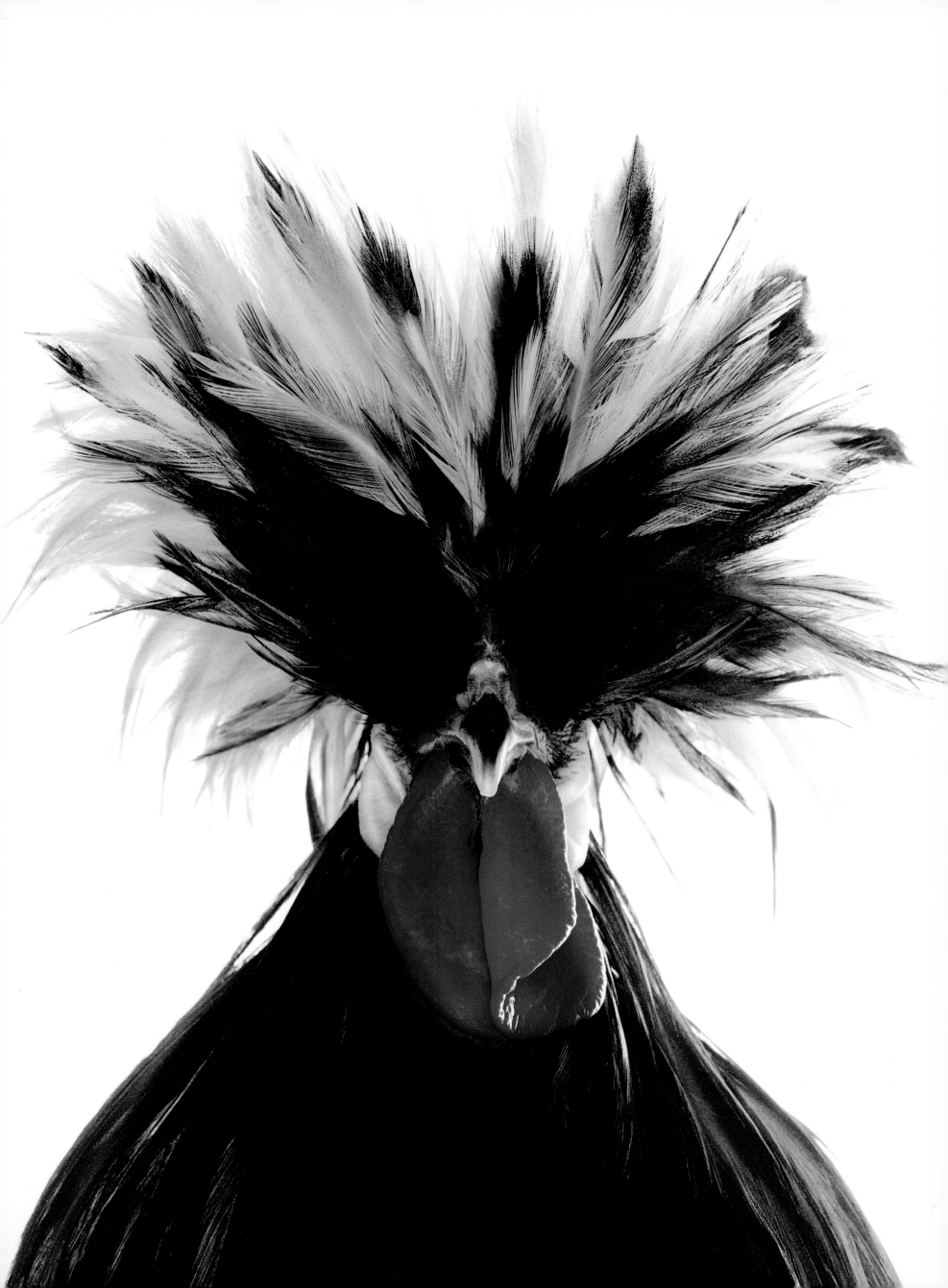

The rooster is an orphan
who has neither a mother nor a father,
and nobody, in search of the mystery
of his origins, dreams of wondering
which came first, the rooster or the egg.

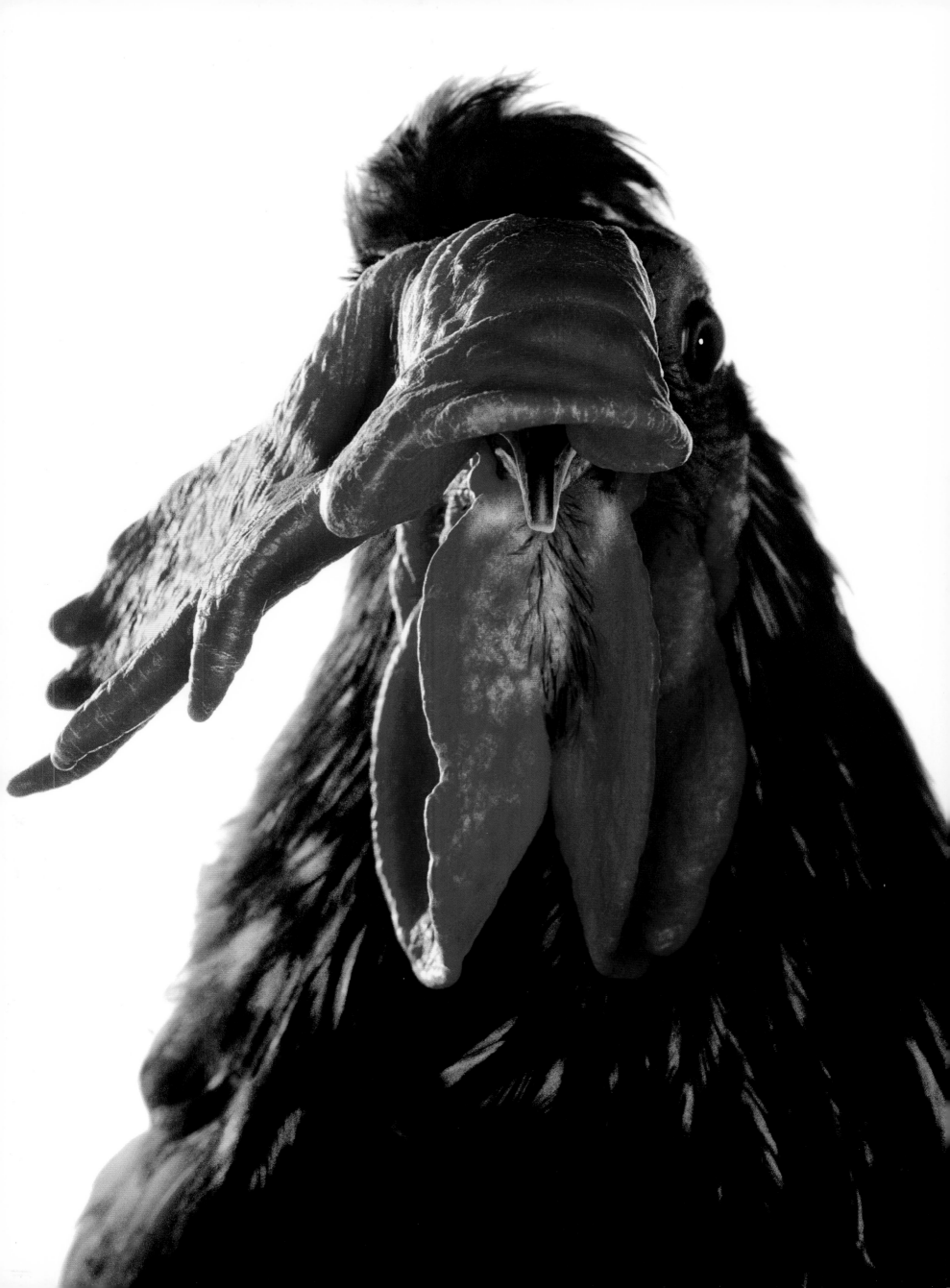

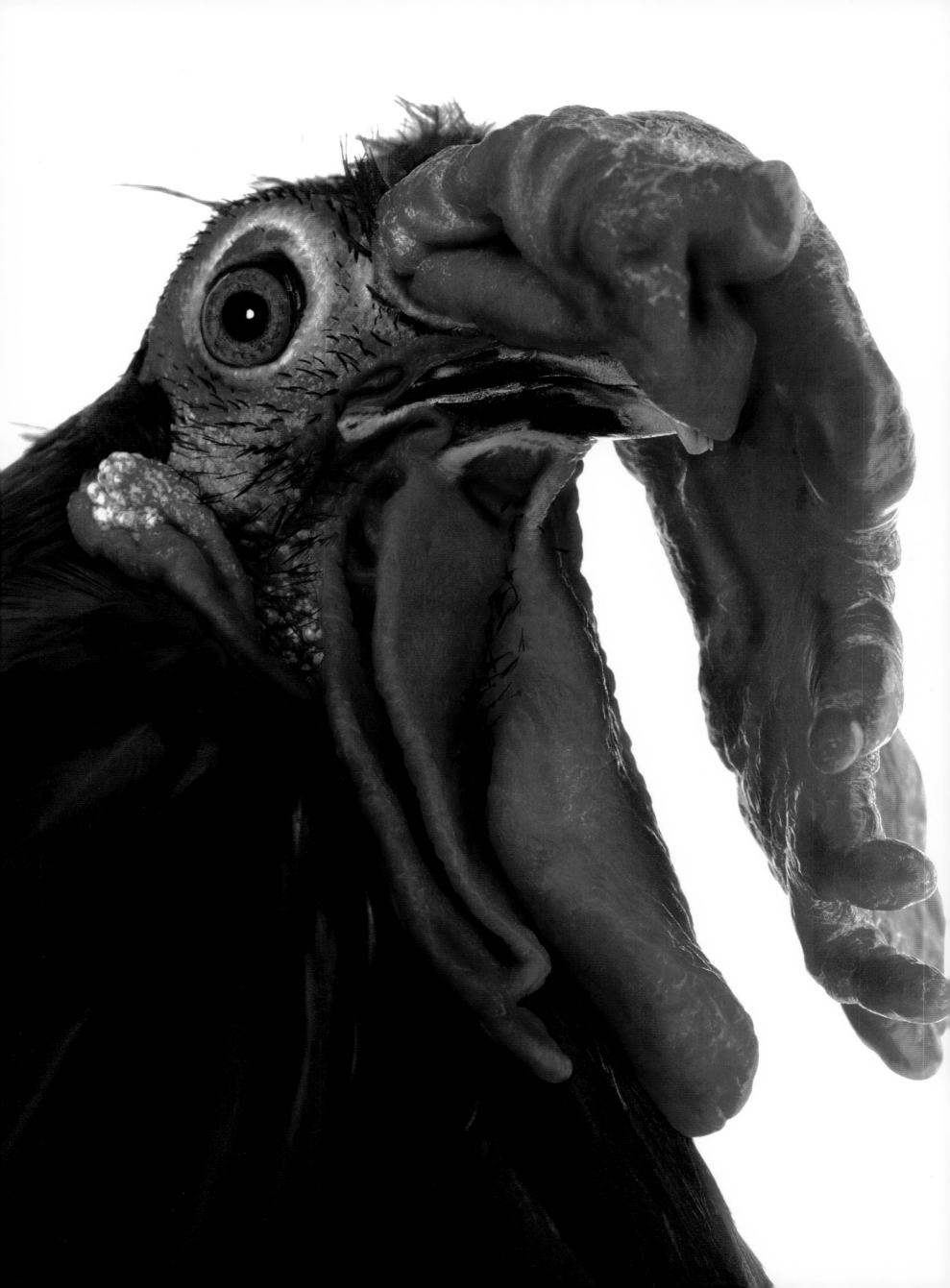

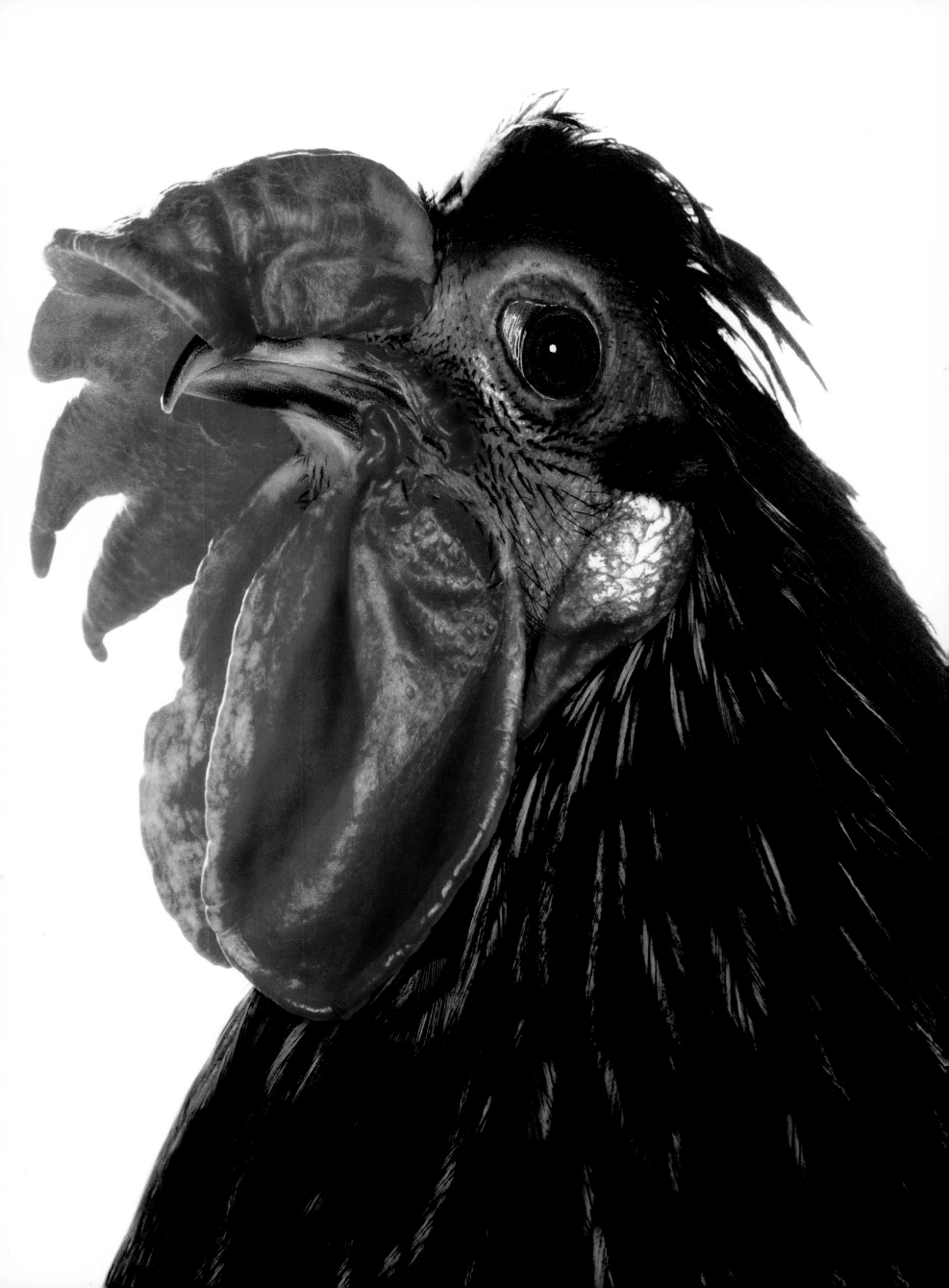

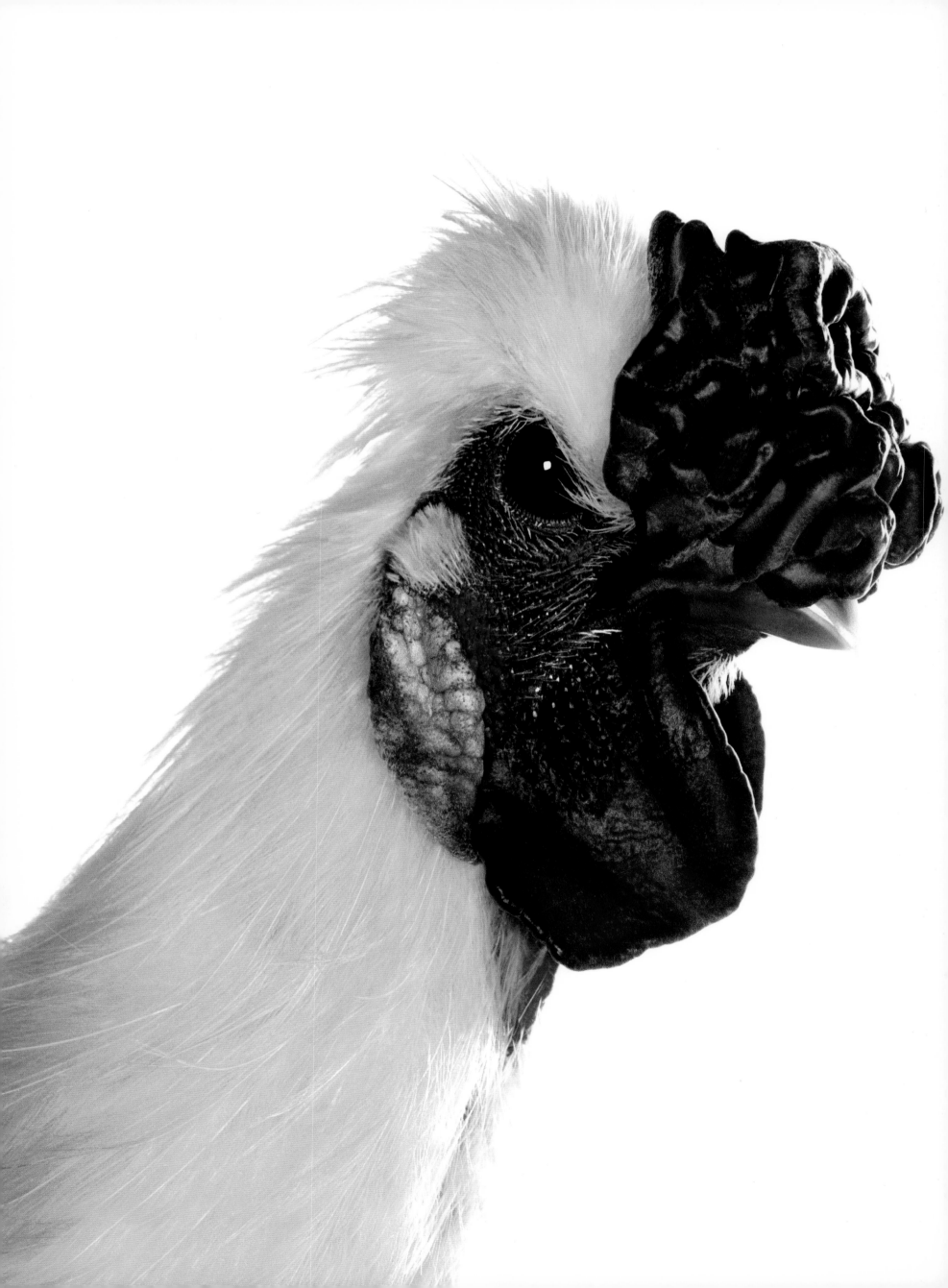

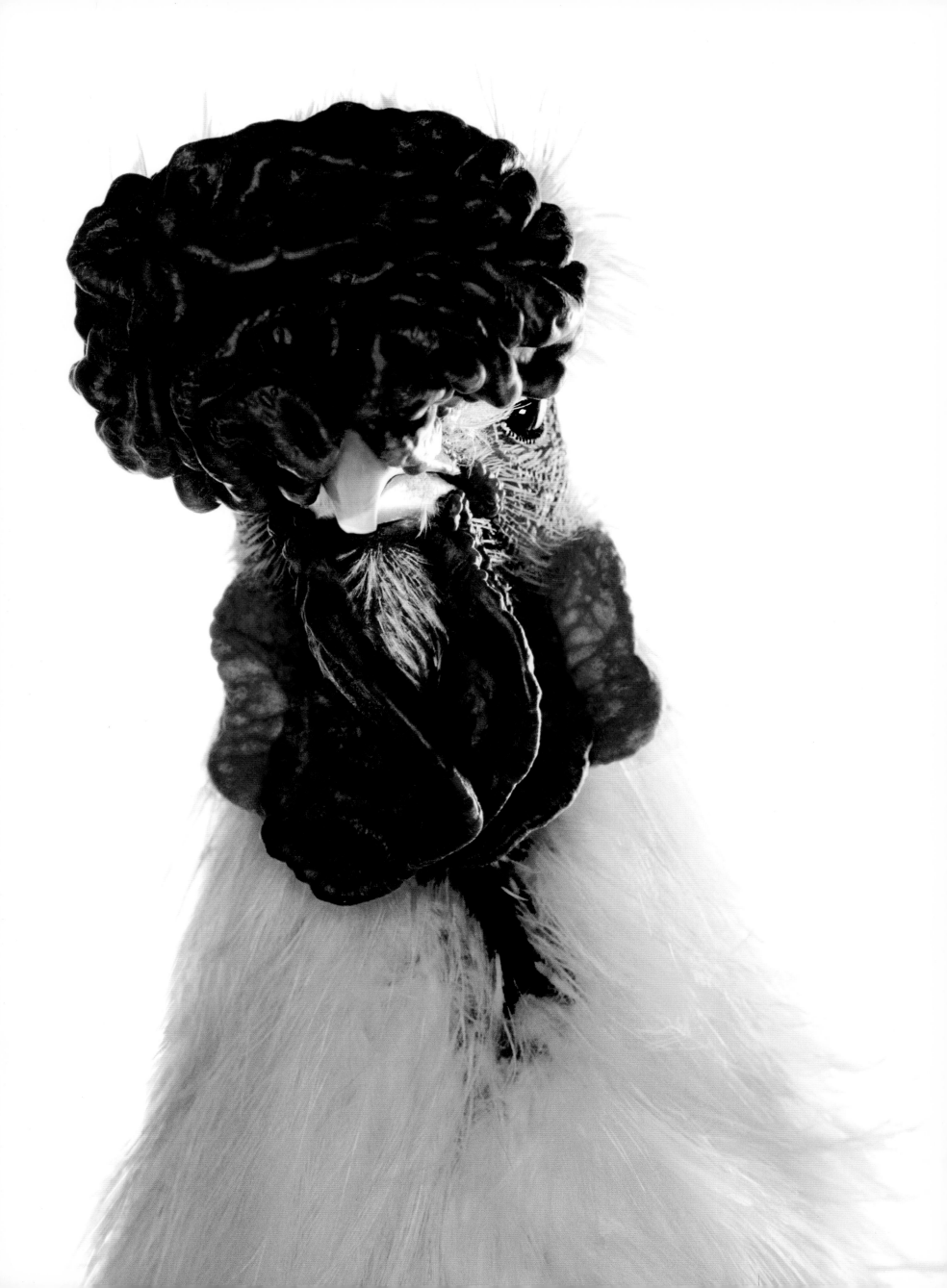

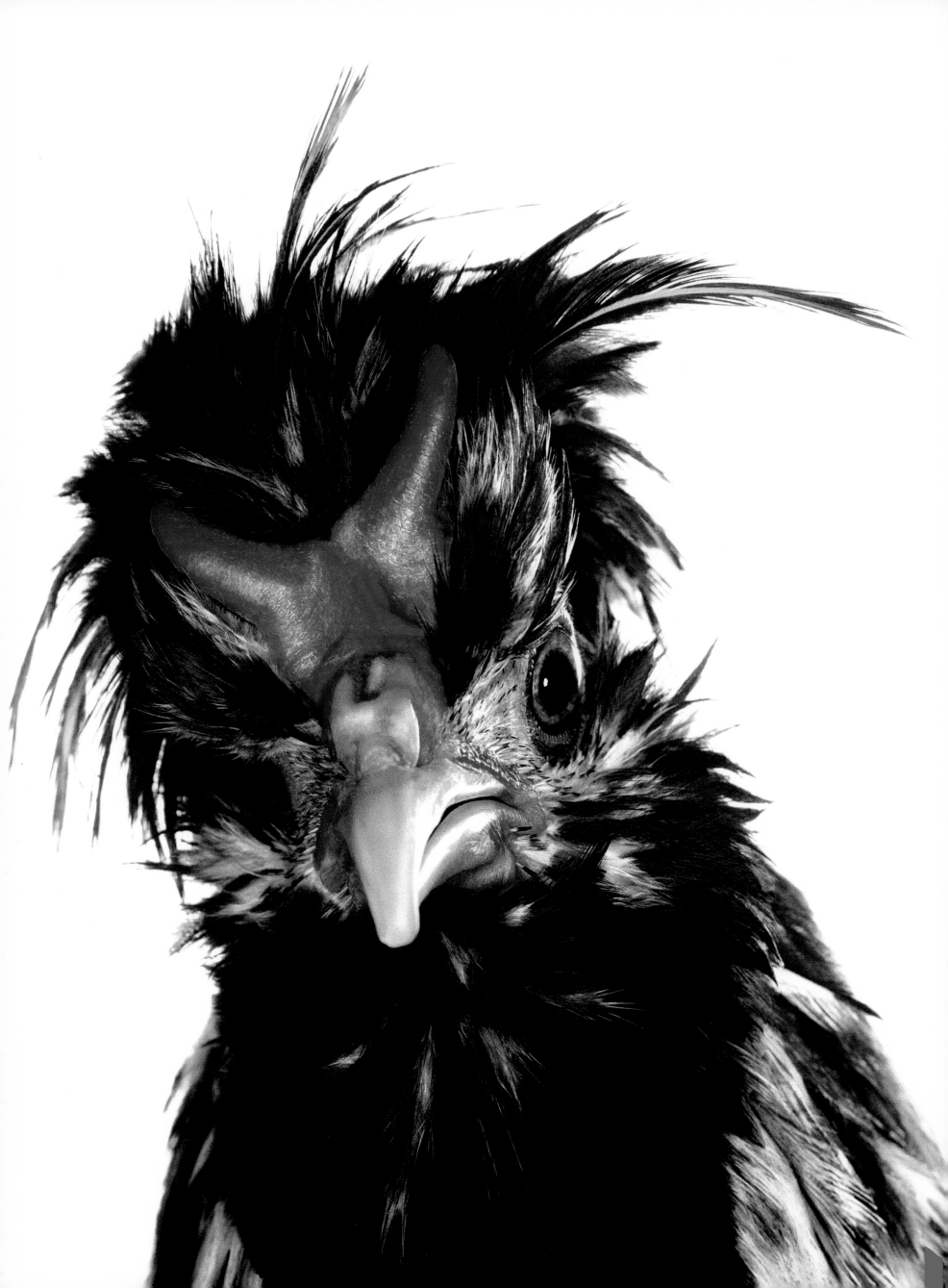

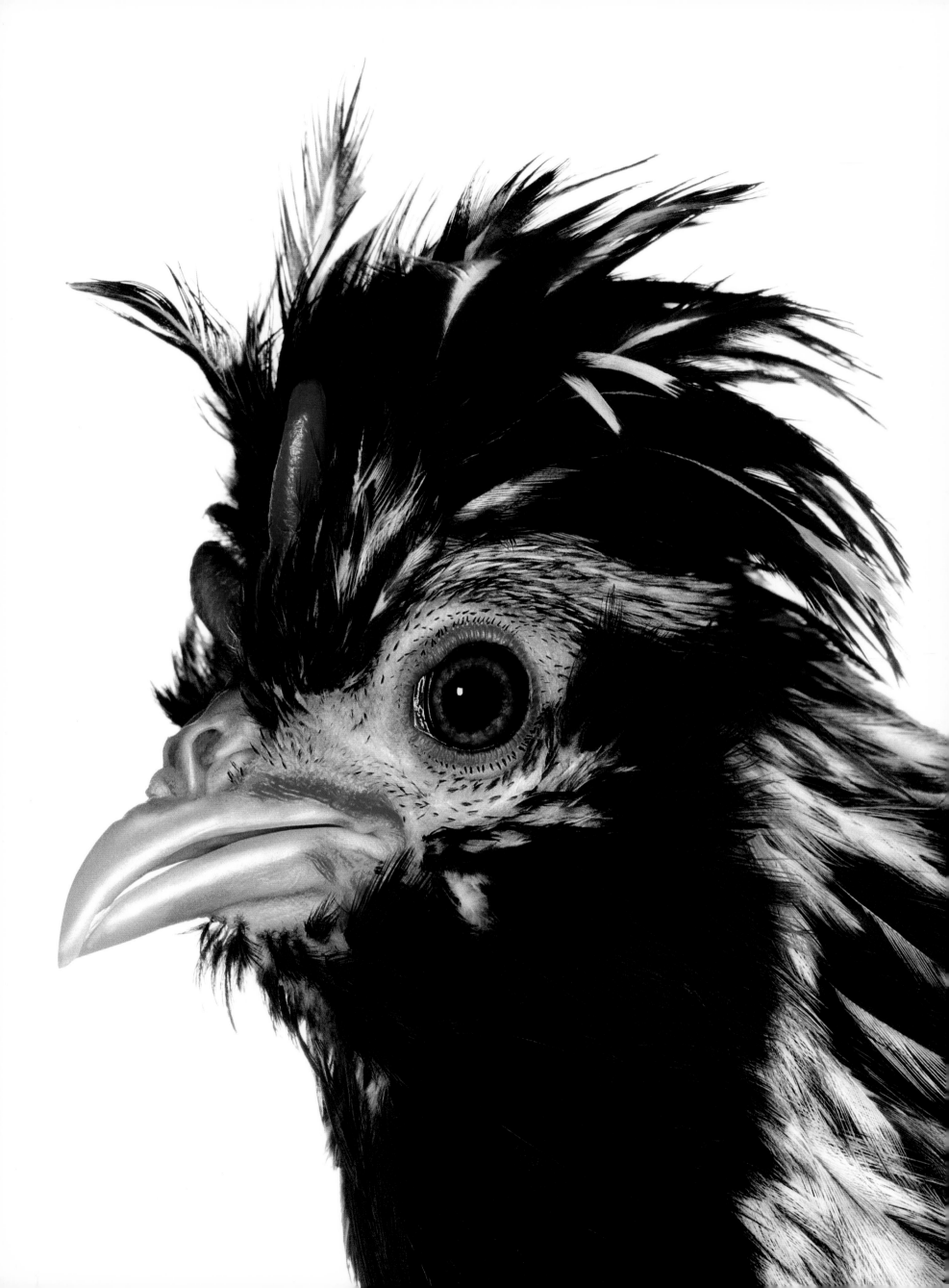

What is missing are not the breeds
but the knowledge we have of them.
Roosters and hens come from Asia, yet
we don't really know their itinerary.

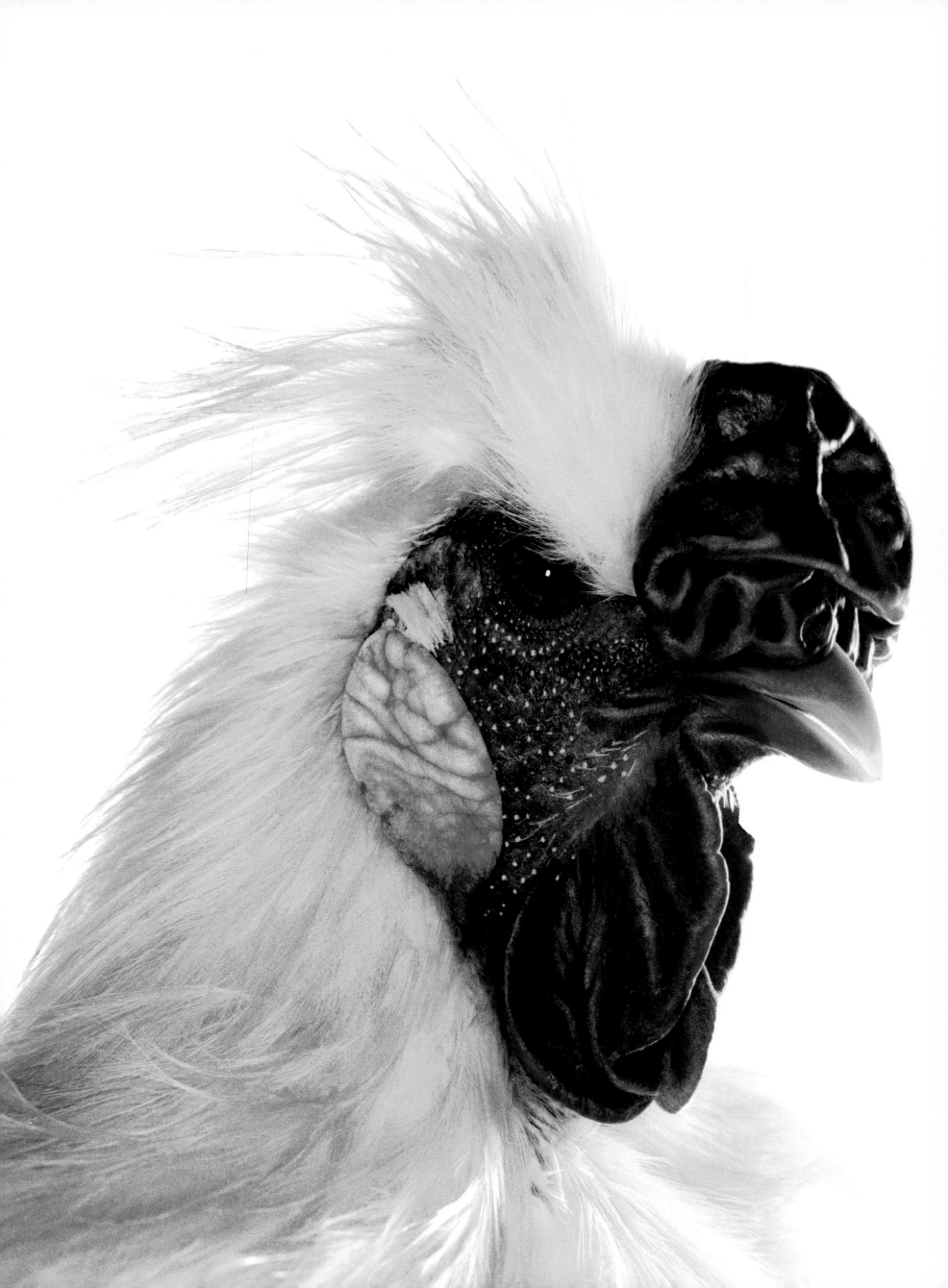

The rooster looks you straight in the eyes,
but he sees you with one eye only;
the other one is on its guard on
the other side of his beak, and a squint
of this sort is true coquetry:
the rooster divides the landscape into
two hemispheres, front and back, or right
and left, one eye north and the other south,
and as his compass is going crazy he
ceaselessly turns his head from side
to side as if he didn't know
these worlds are actually just one.

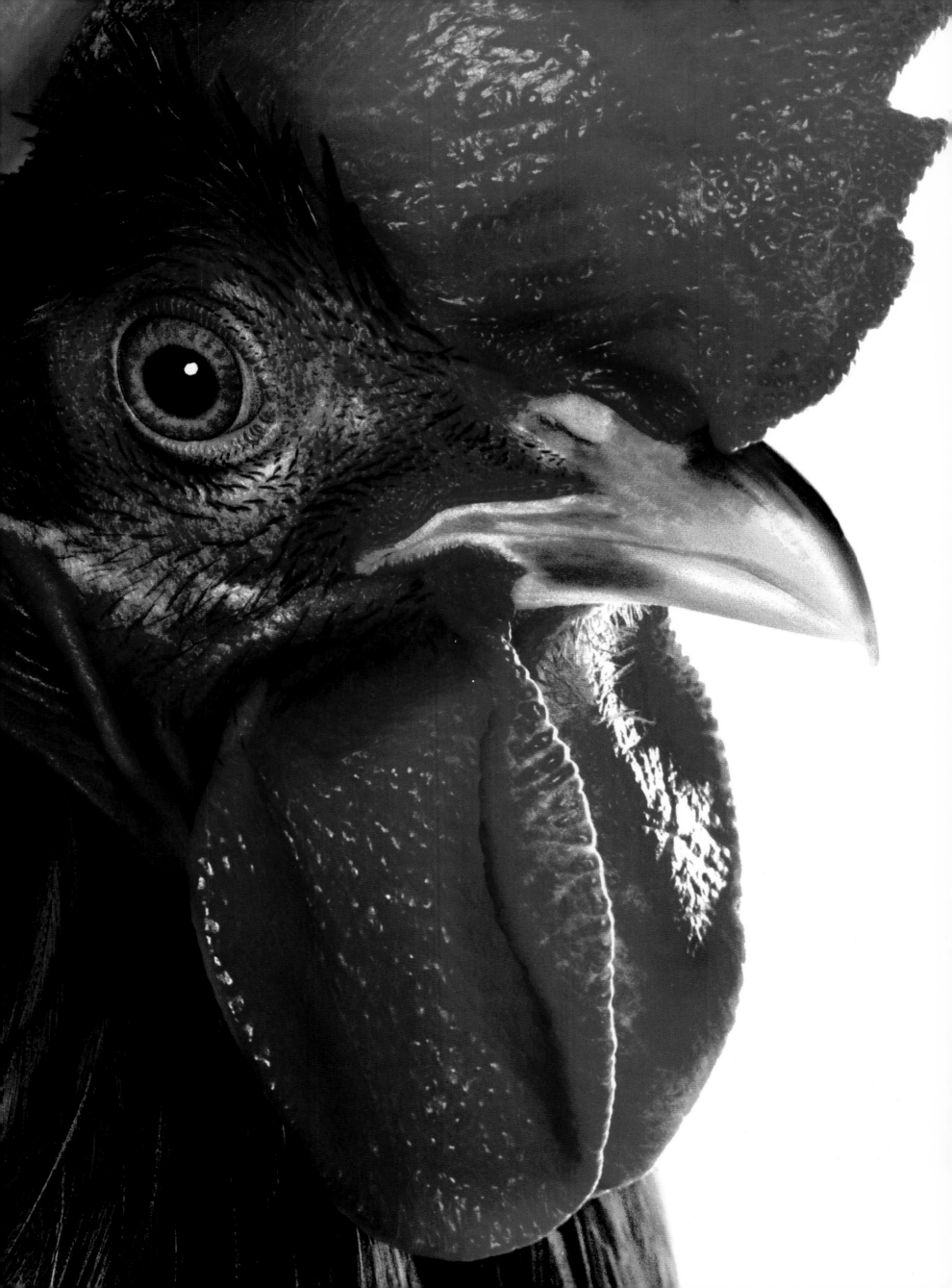

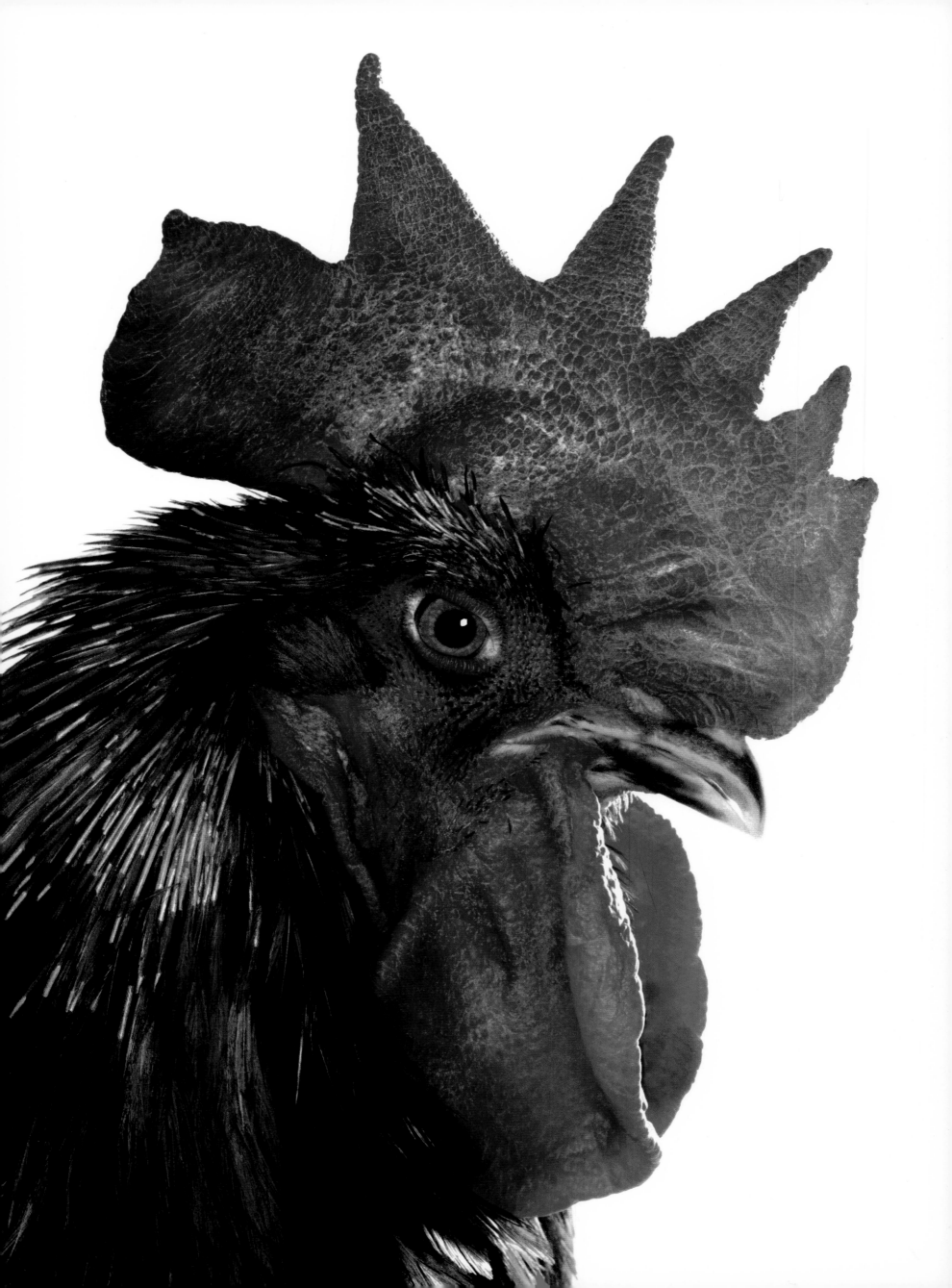

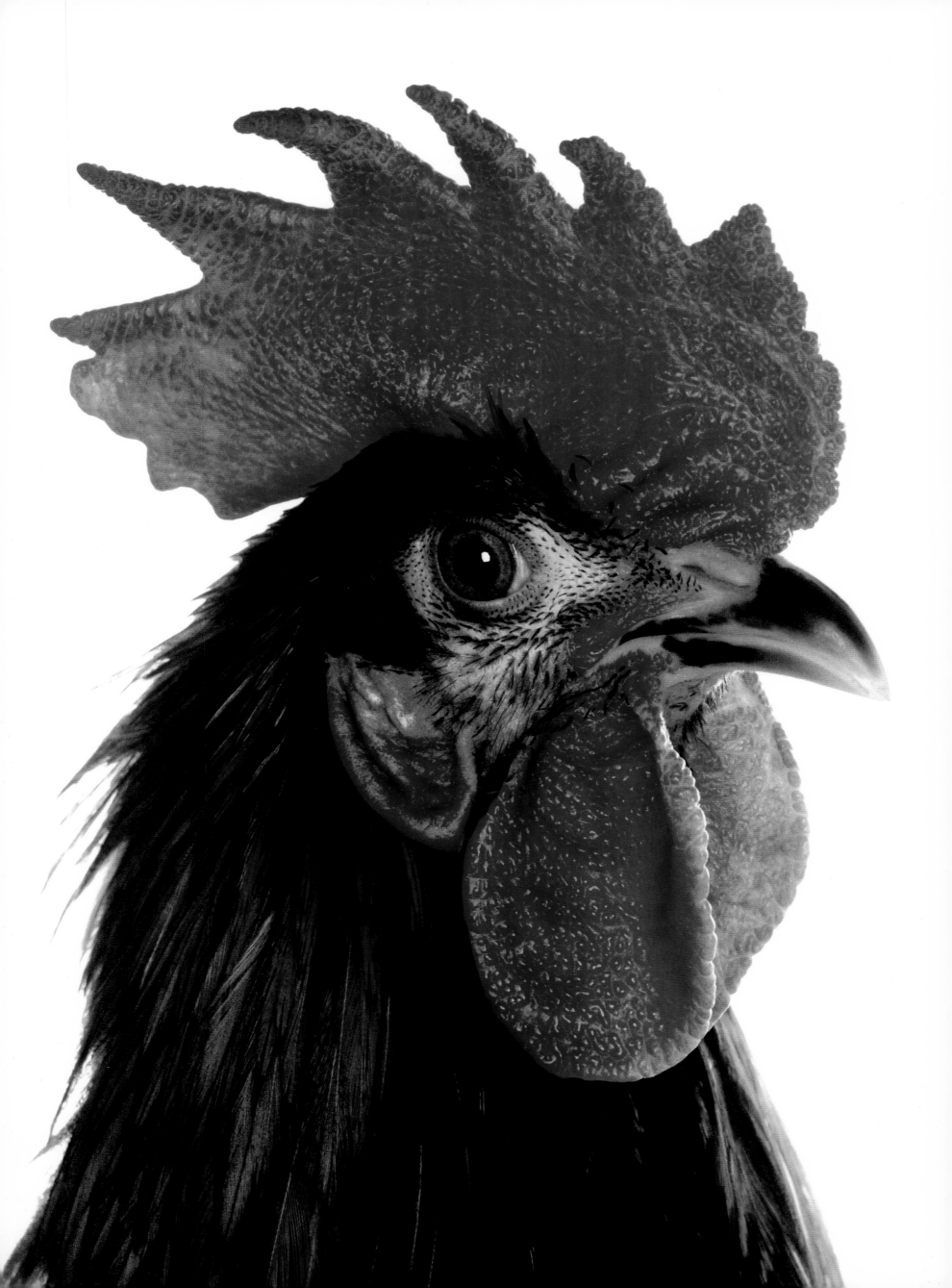

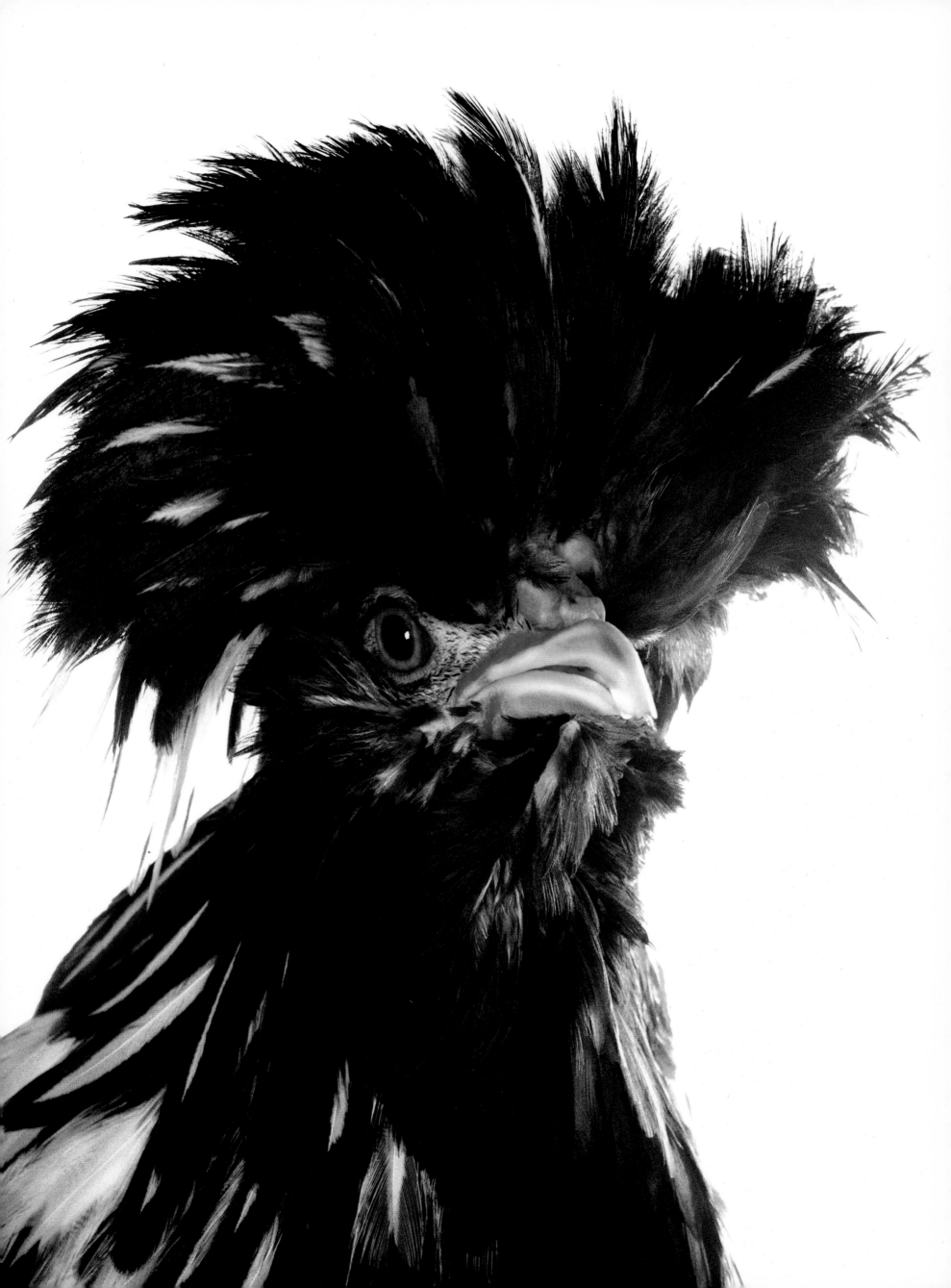

He stretches his neck and puffs up
with pride. He wears a feathered ruffle
that he believes is made of lace,
a red crest decorated with fleshy caruncles,
and these soft warts are his jewelry.

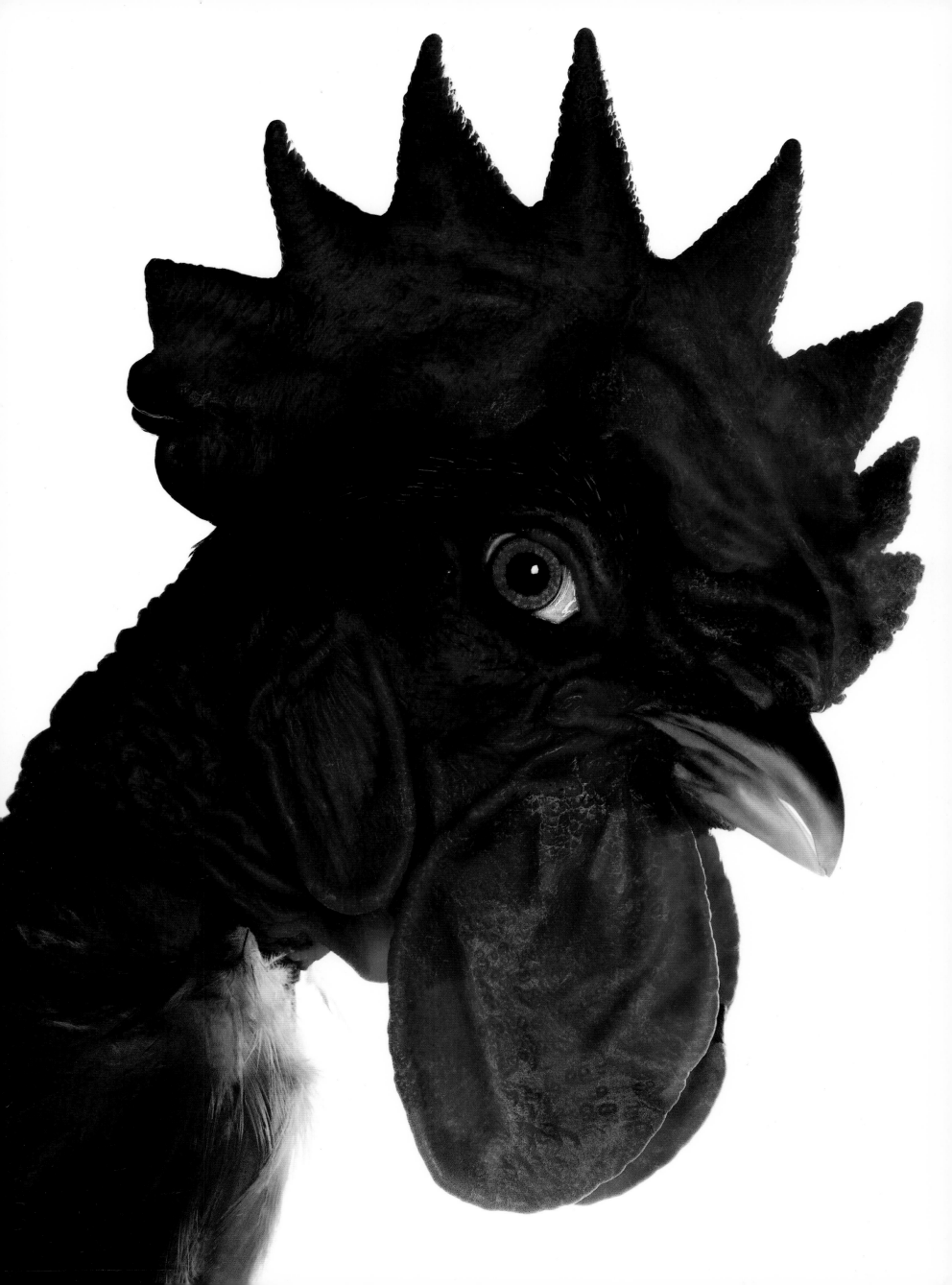

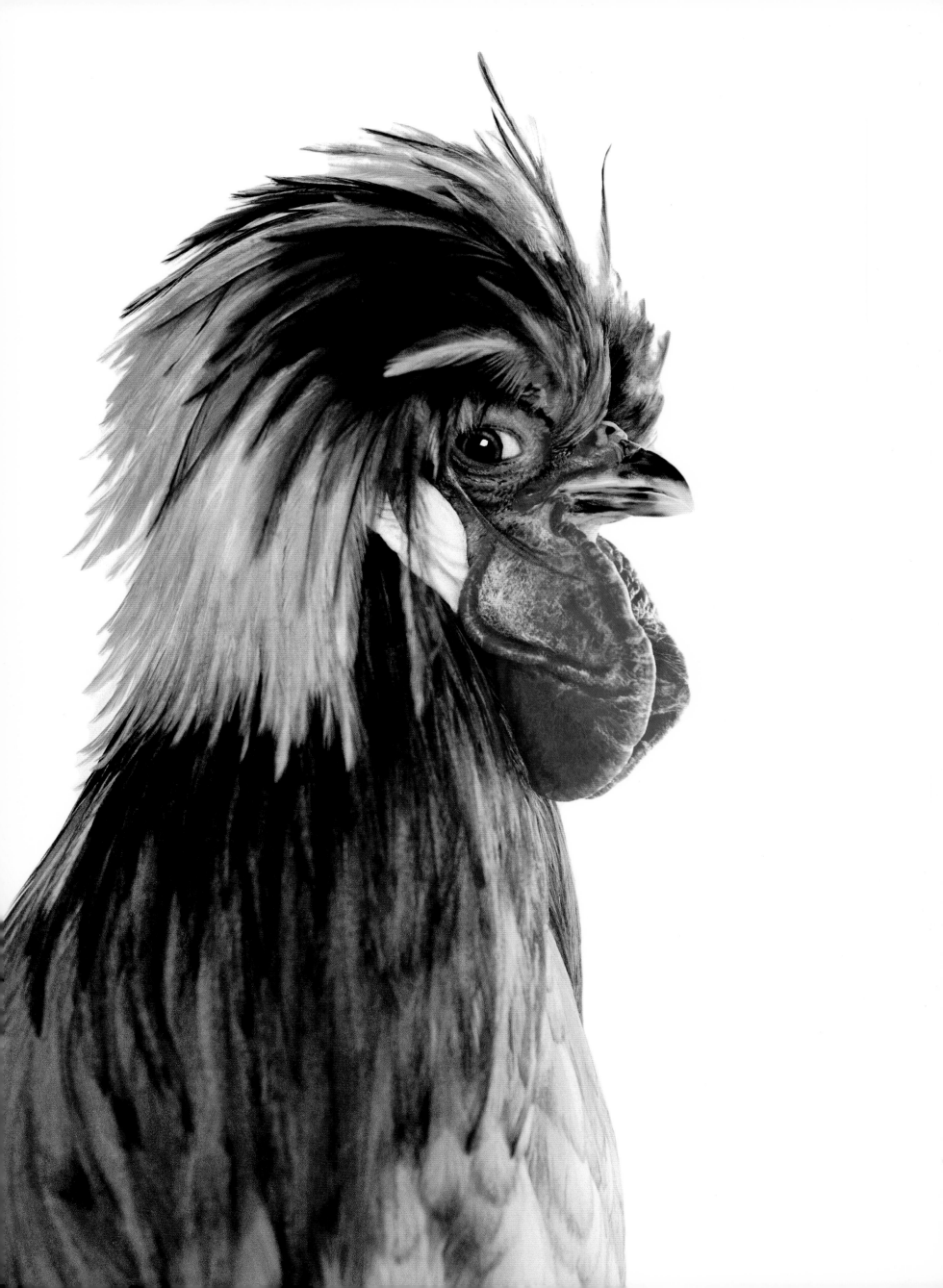

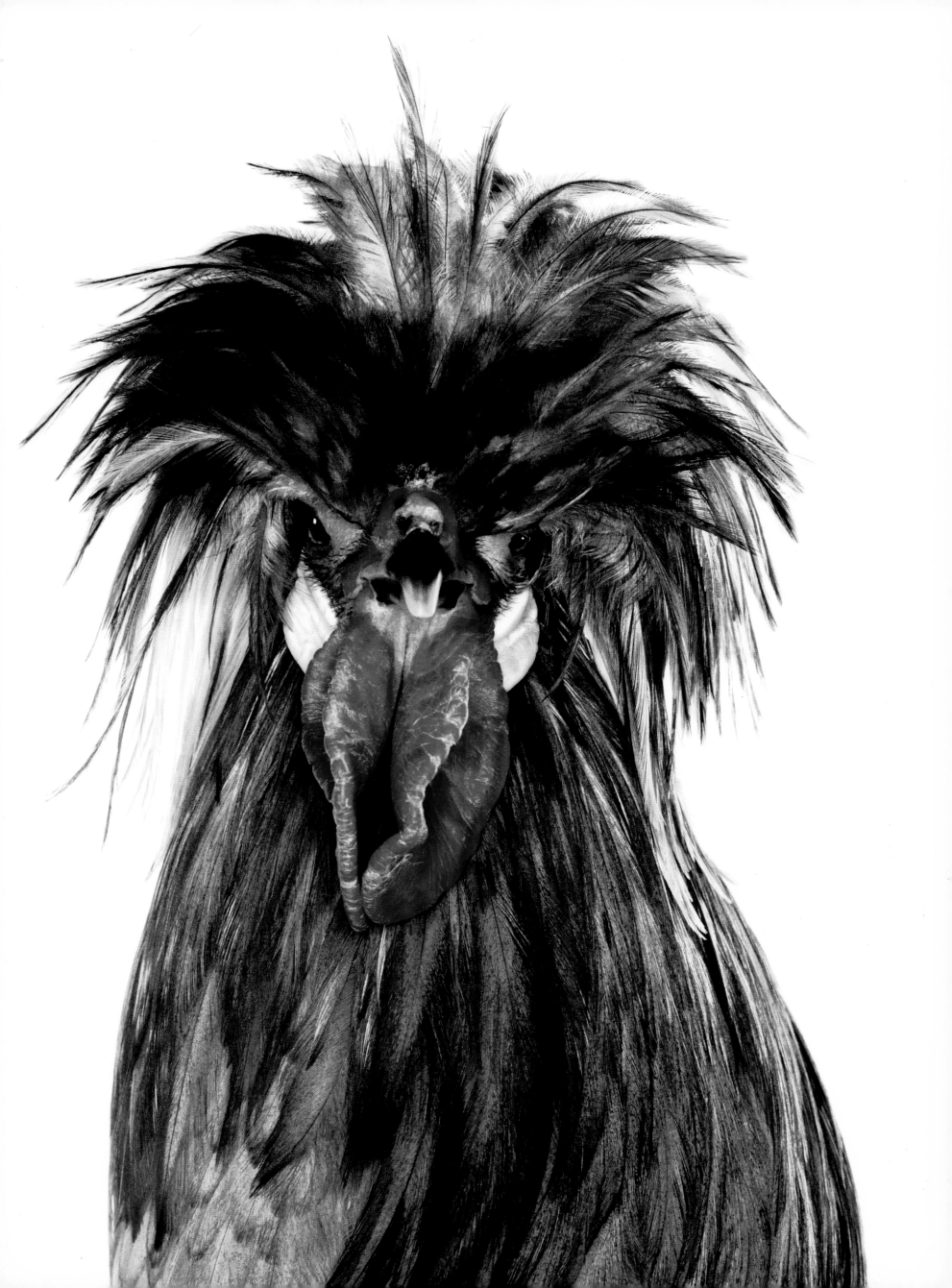

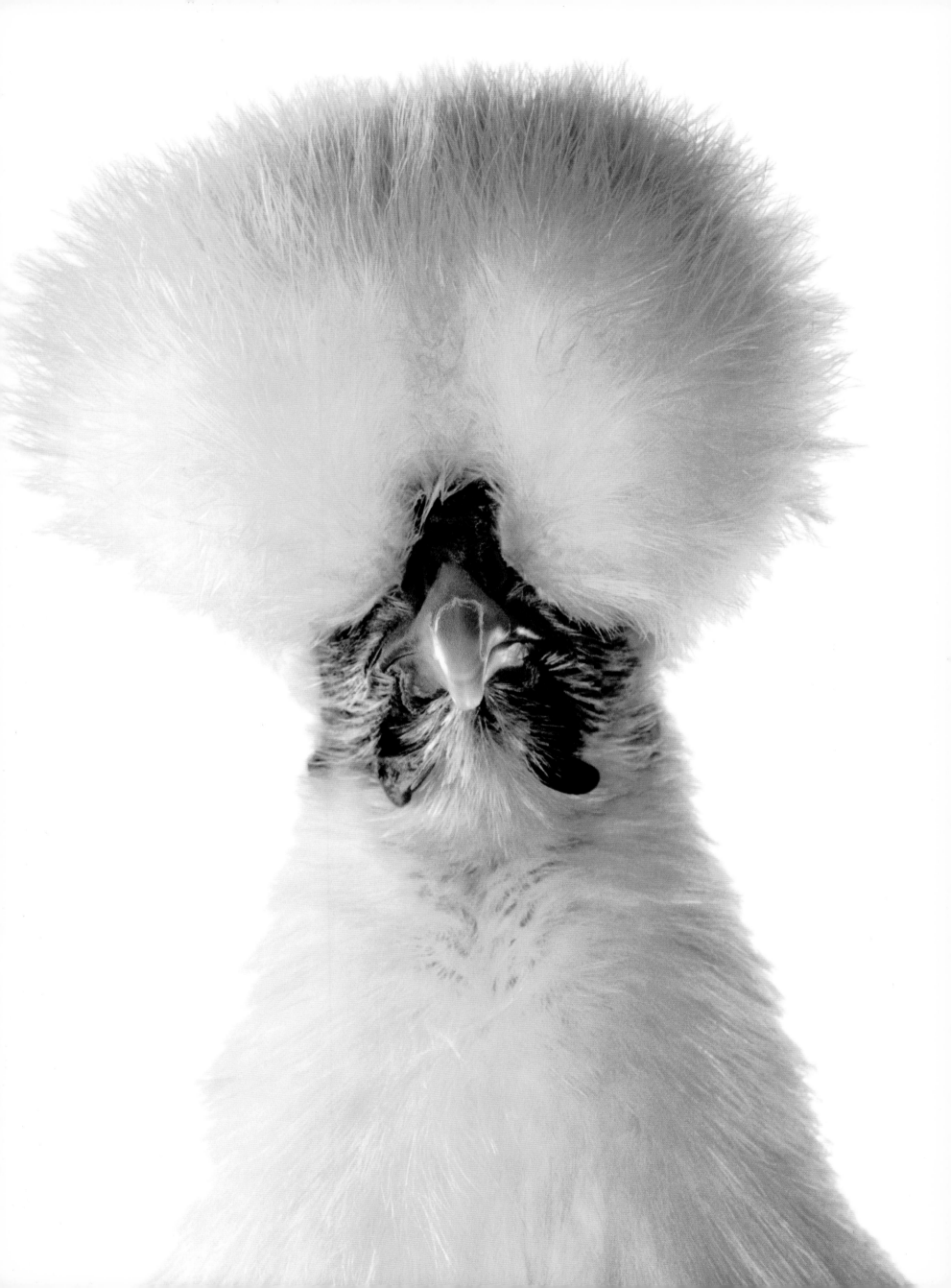

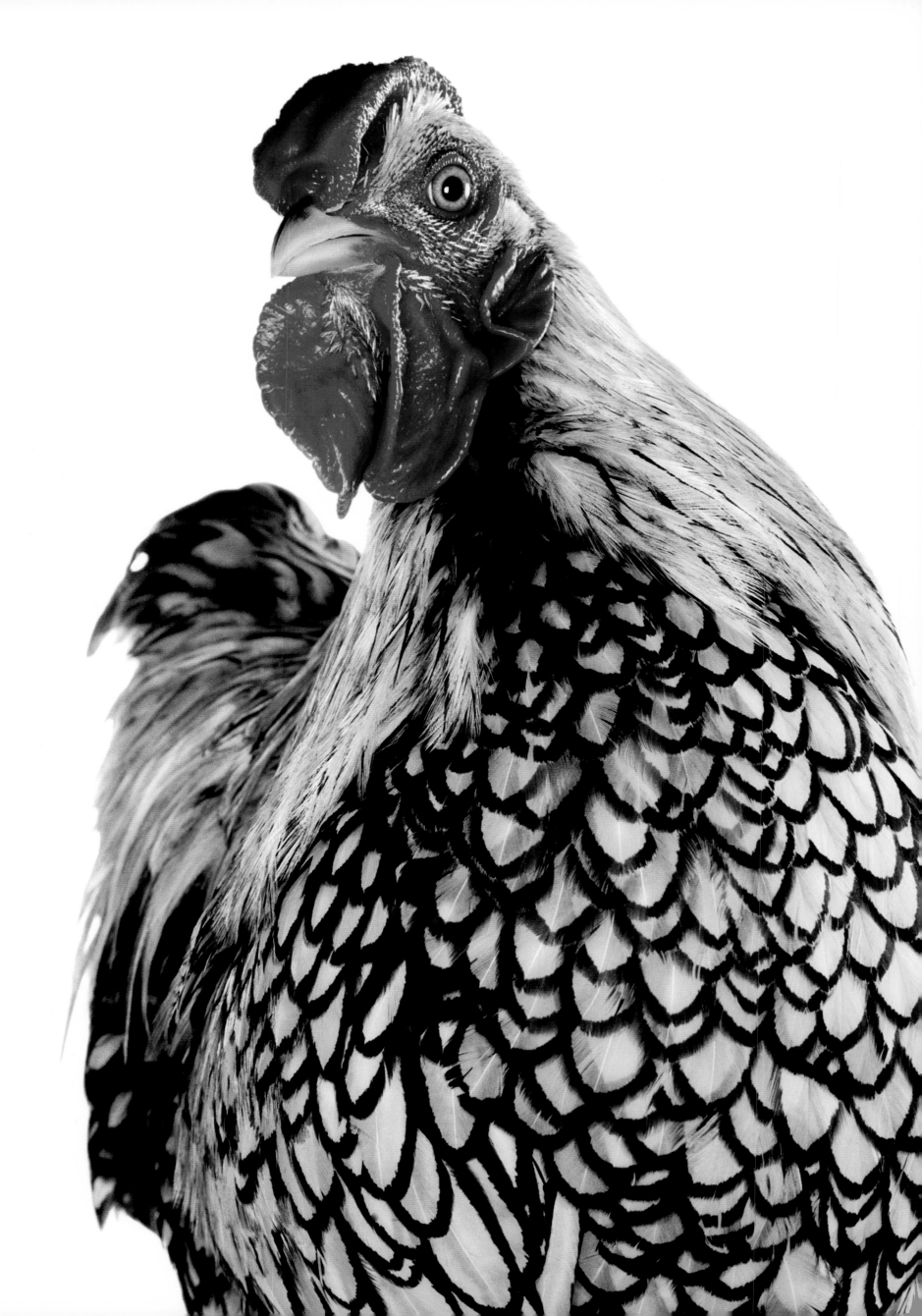

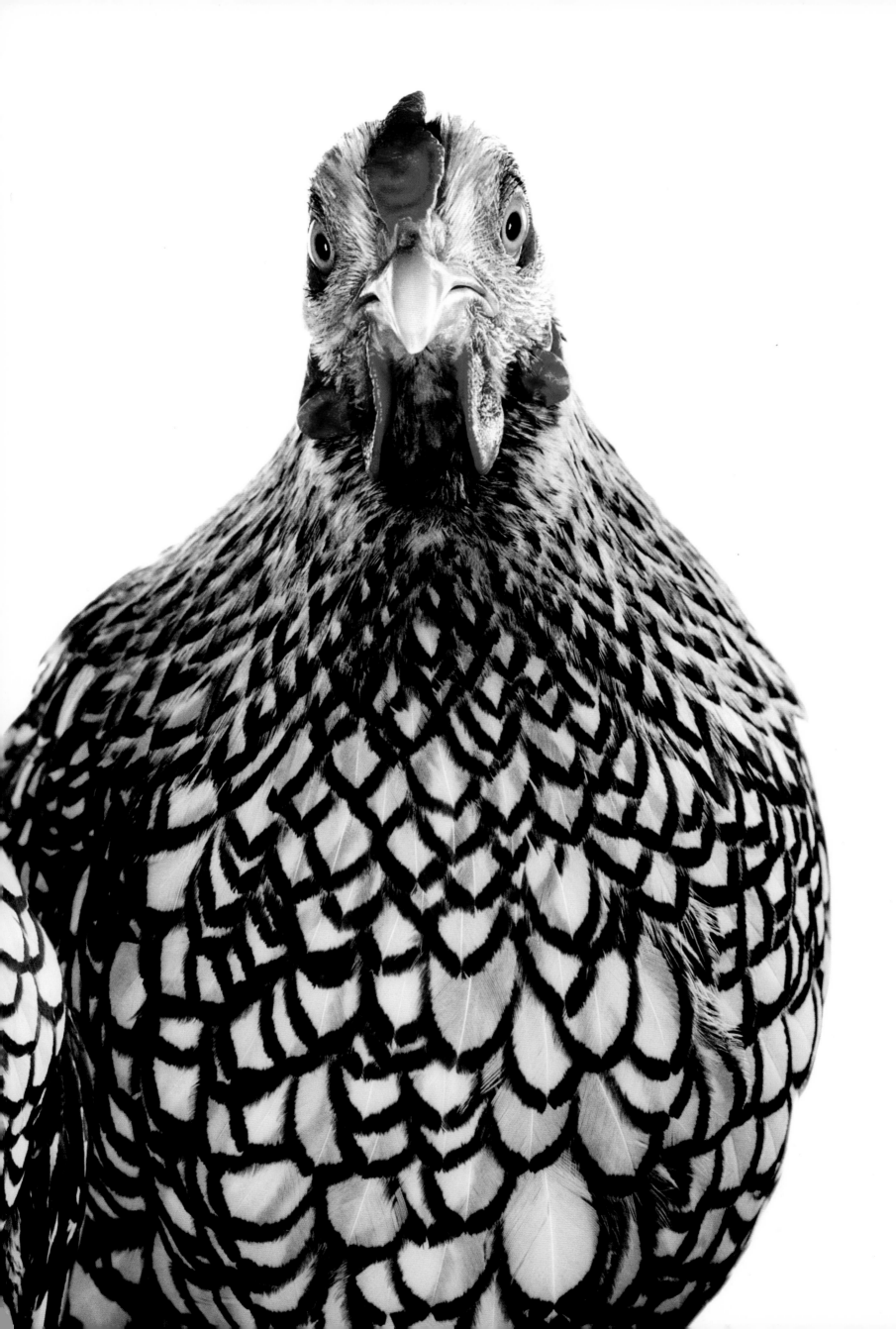

It's not because he's capped with
a crest that the rooster is a cretin,
no, it's because he ate the serpent
instead of munching the apple.
Since then, he's happy with
earthworms and dropped seeds, while
fruit is too high for his sluggish wings.

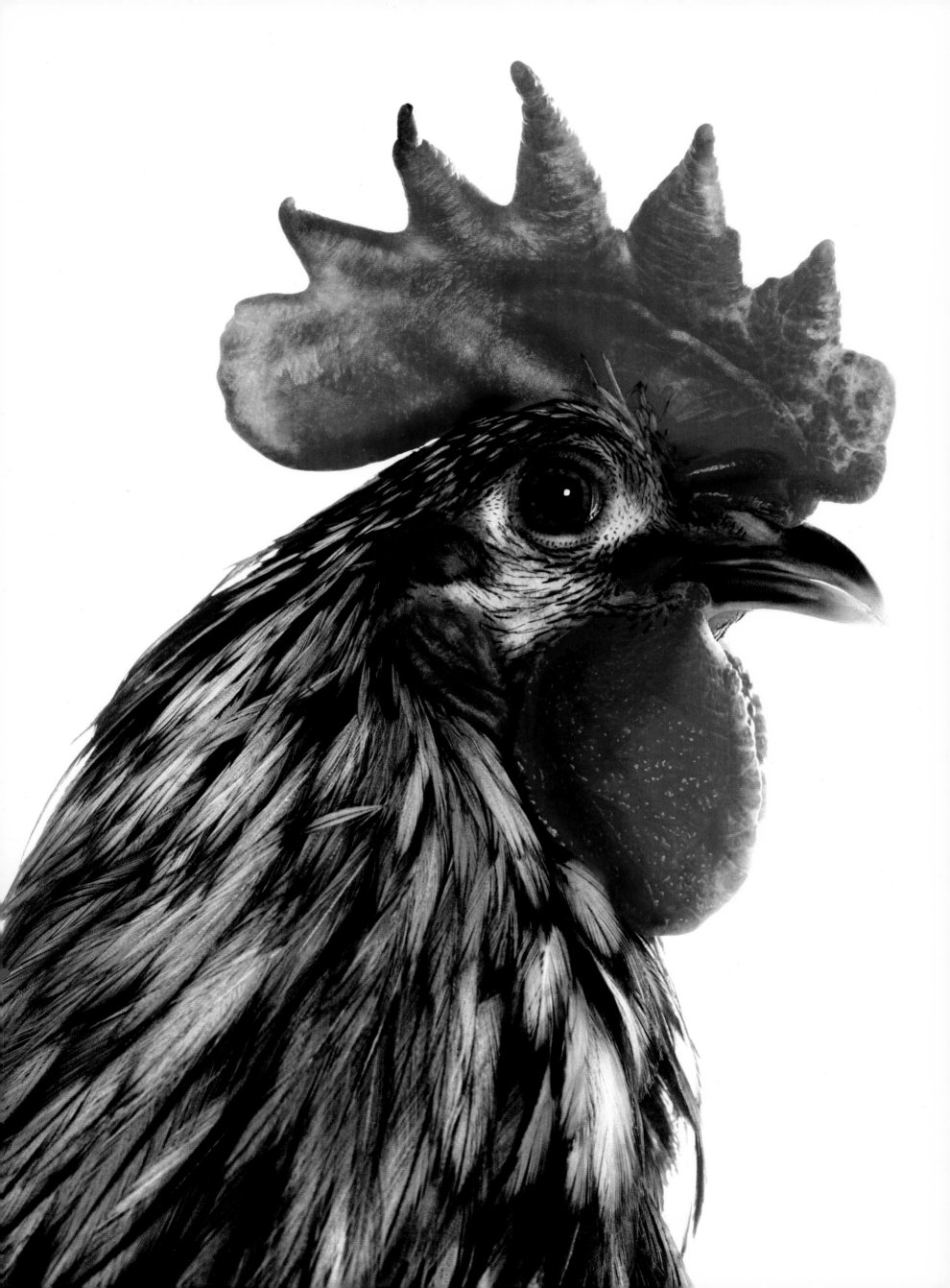

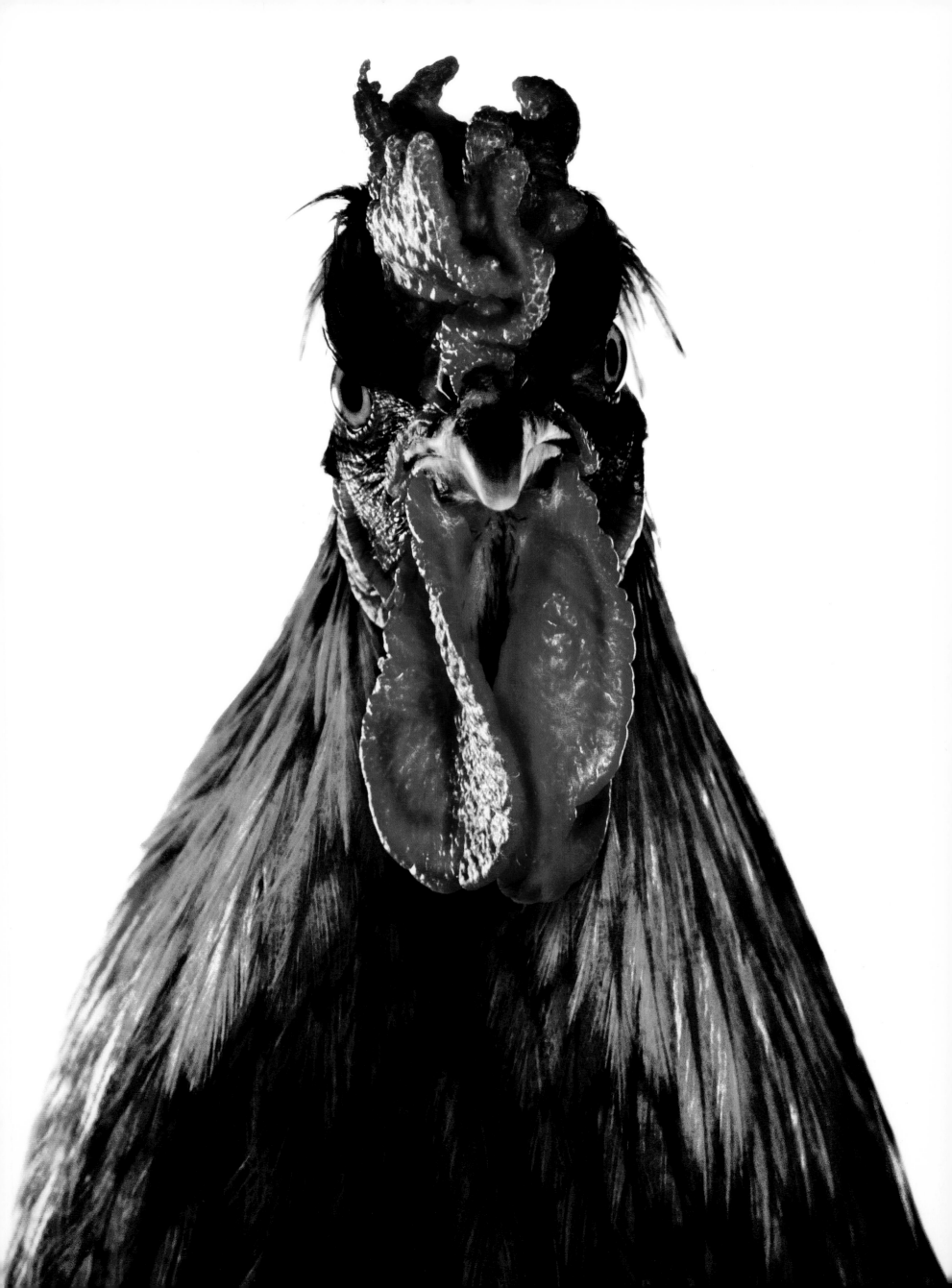

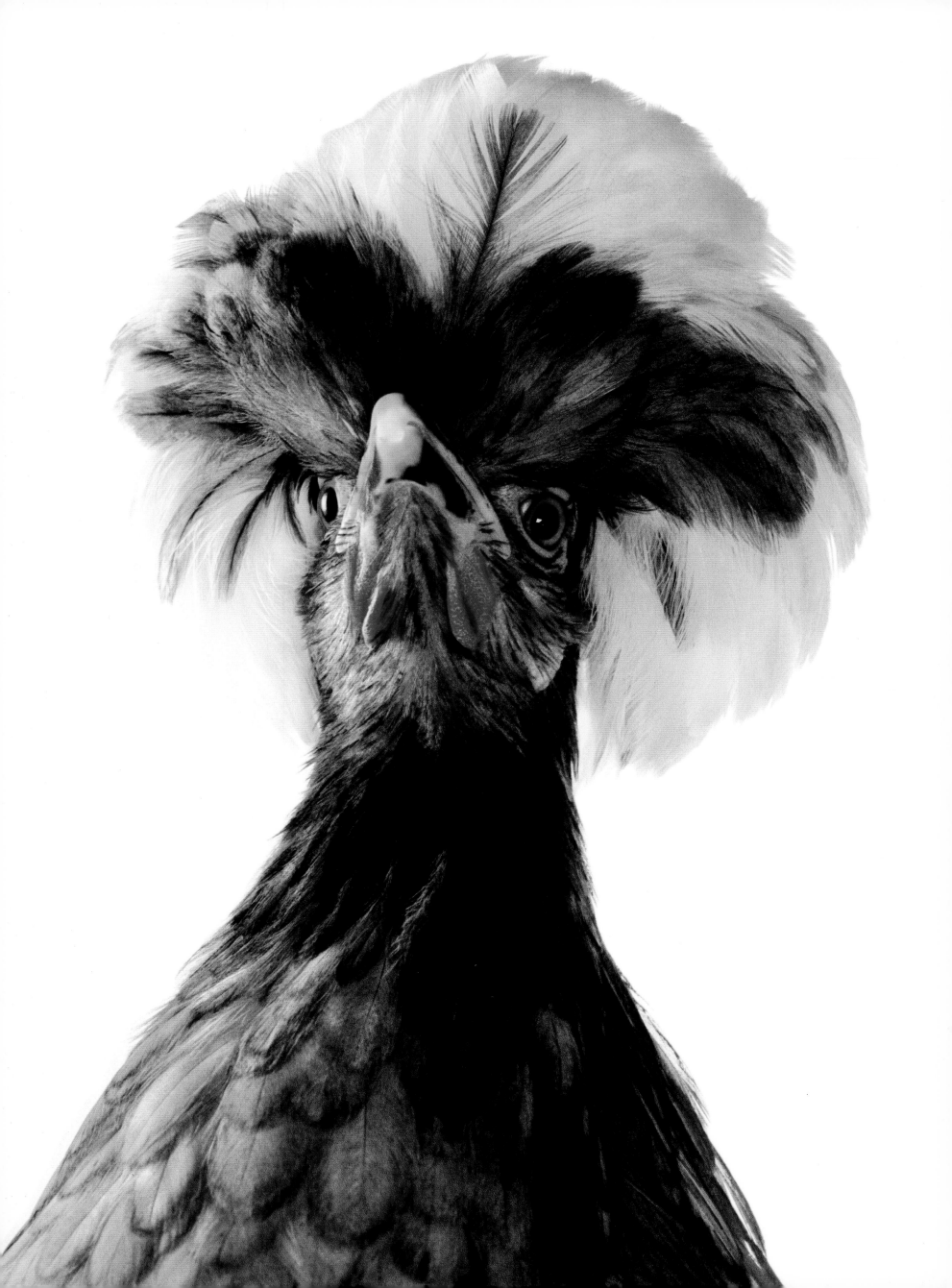

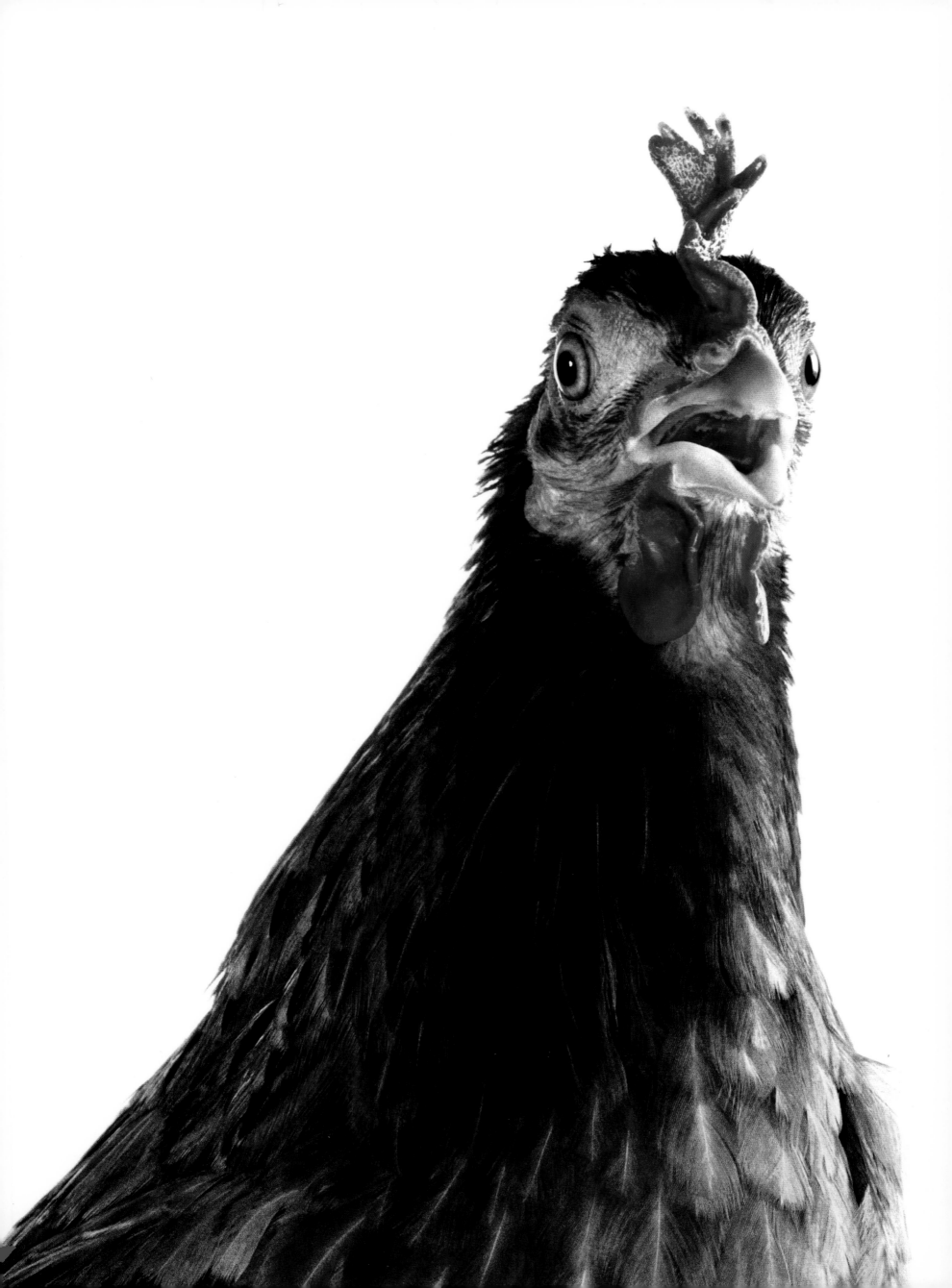

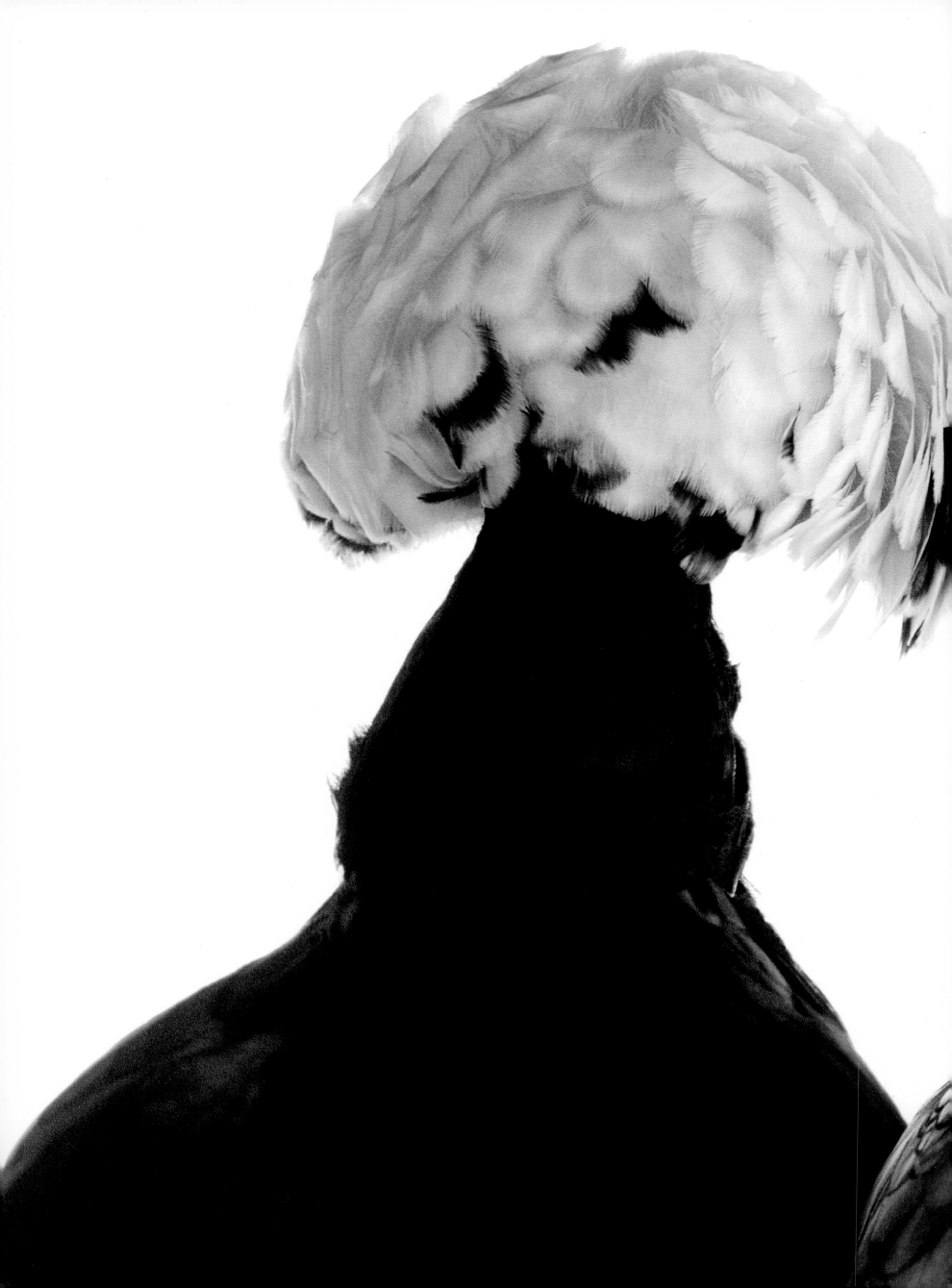

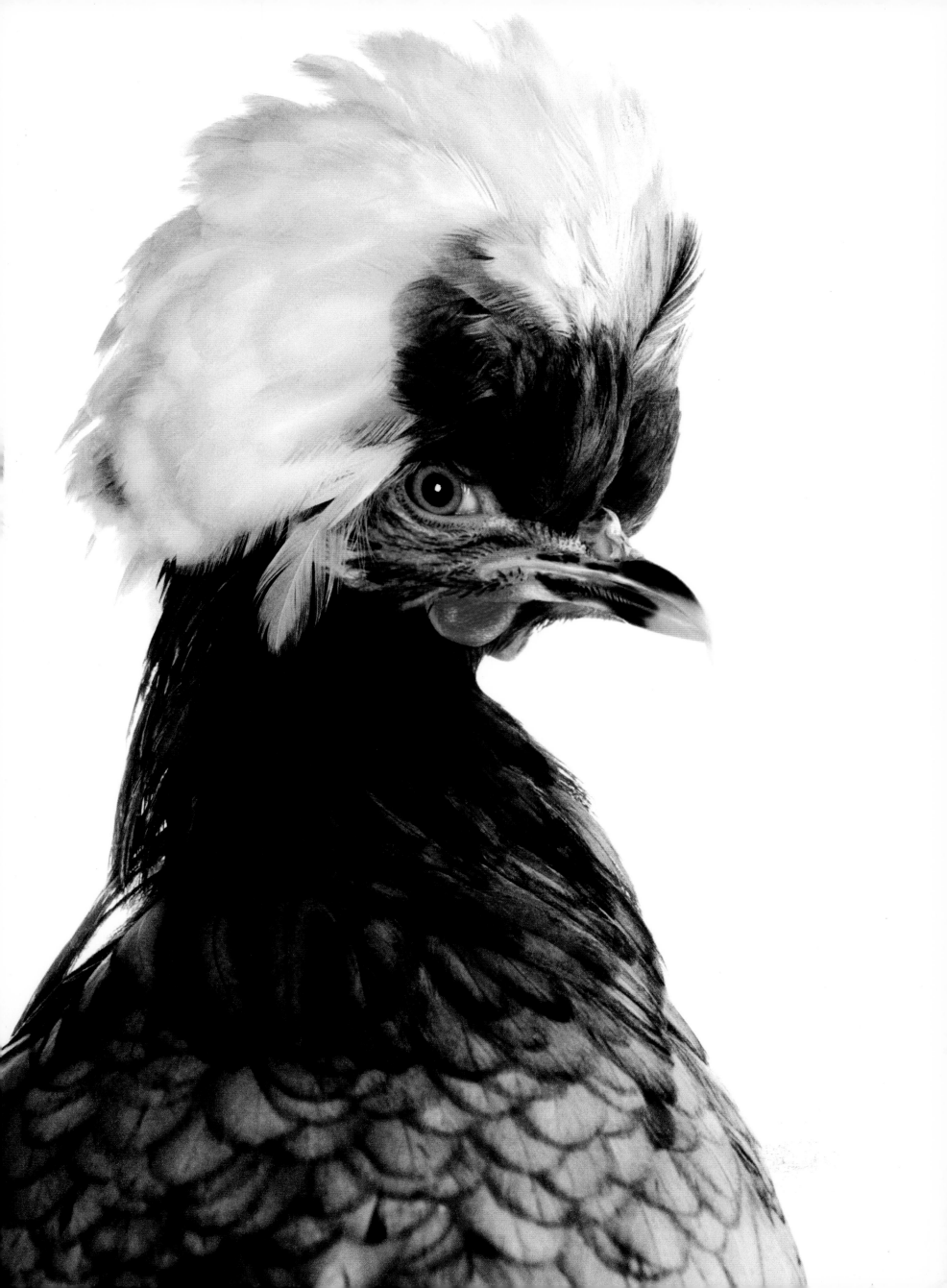

Darwin dates the trace of rooster
and hen in Europe to six centuries
before our era. Socrates already complained
of them saying that he tolerated his hens'
screeching only because they gave him eggs
and his wife's, Xanthippe, only because
she gave him children.

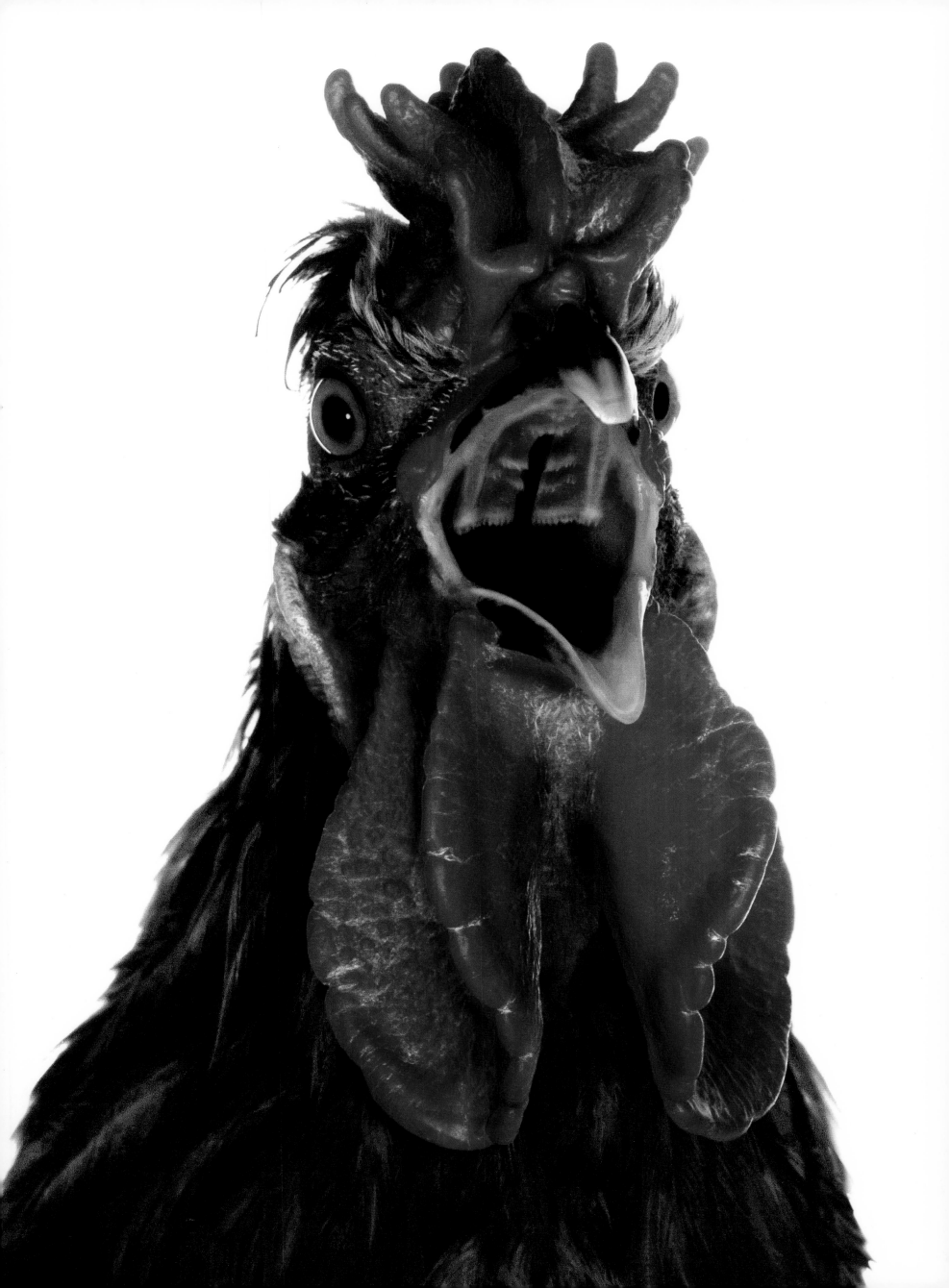

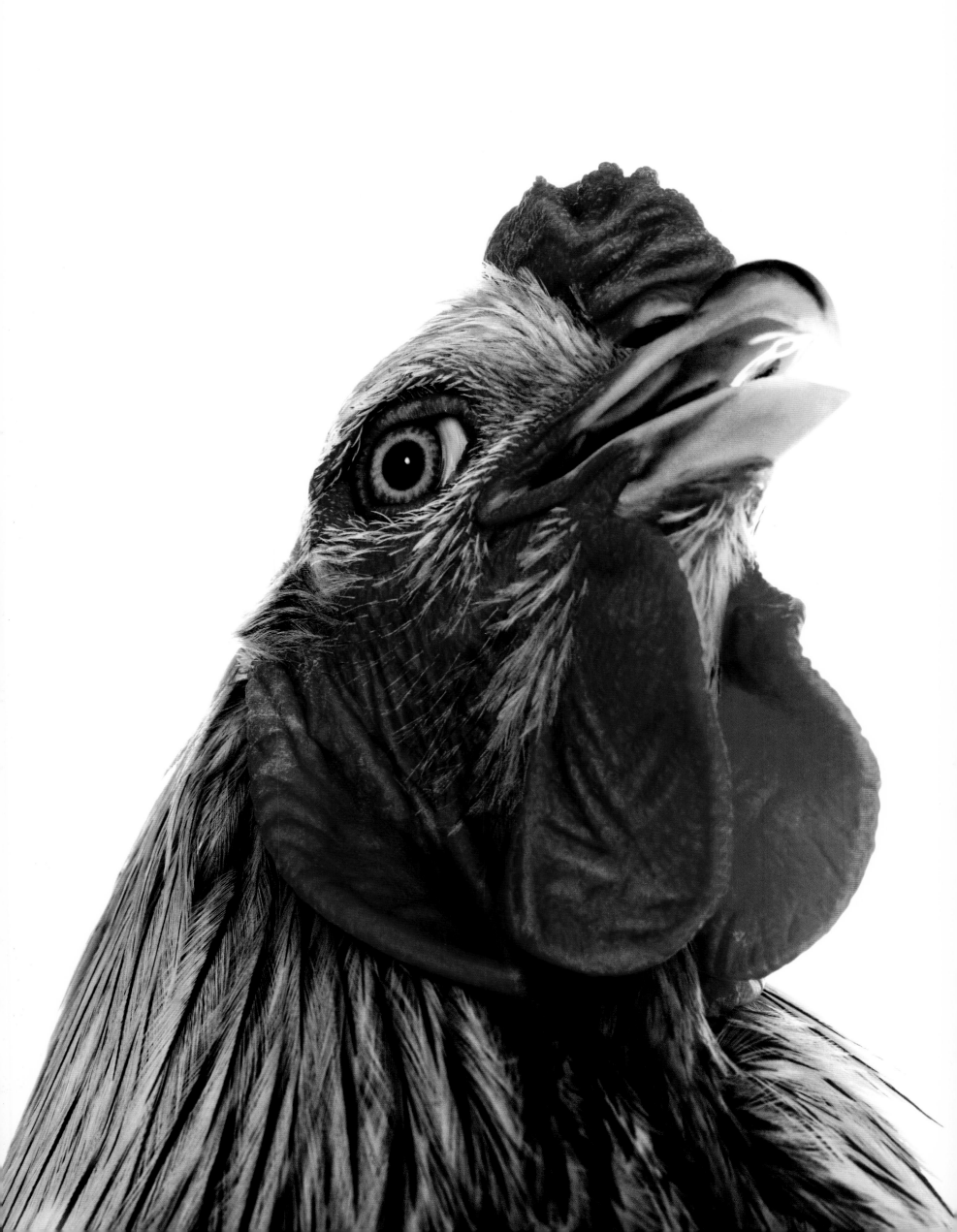

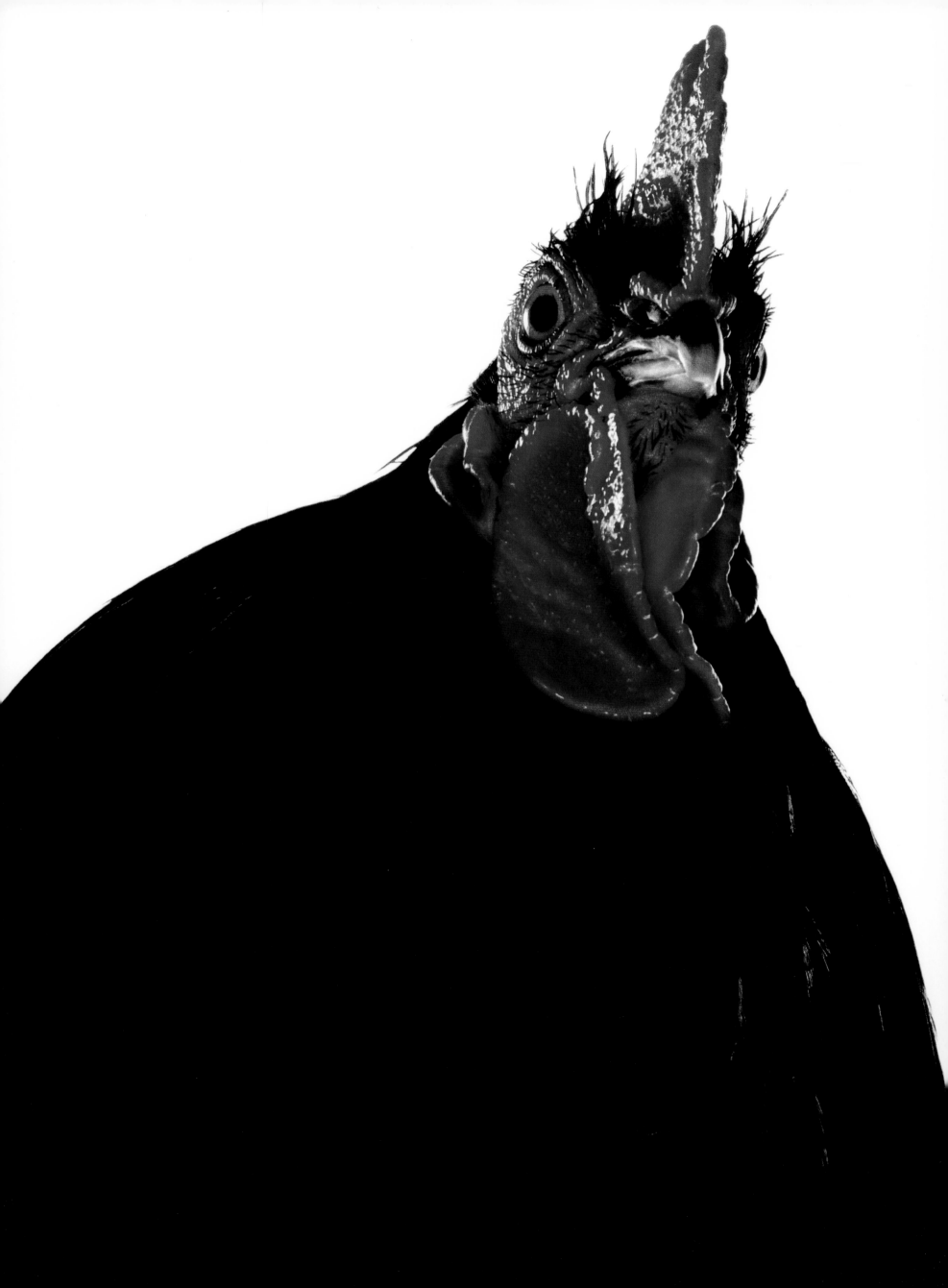

Man and rooster unequally share two
practices that ought to bring them closer:
on the one hand, the rooster is polygamous,
as man sometimes is; on the other hand,
even if man and rooster are whole,
normally speaking, it might be suggested
that capon is to rooster what eunuch
is to man—a fatty body.

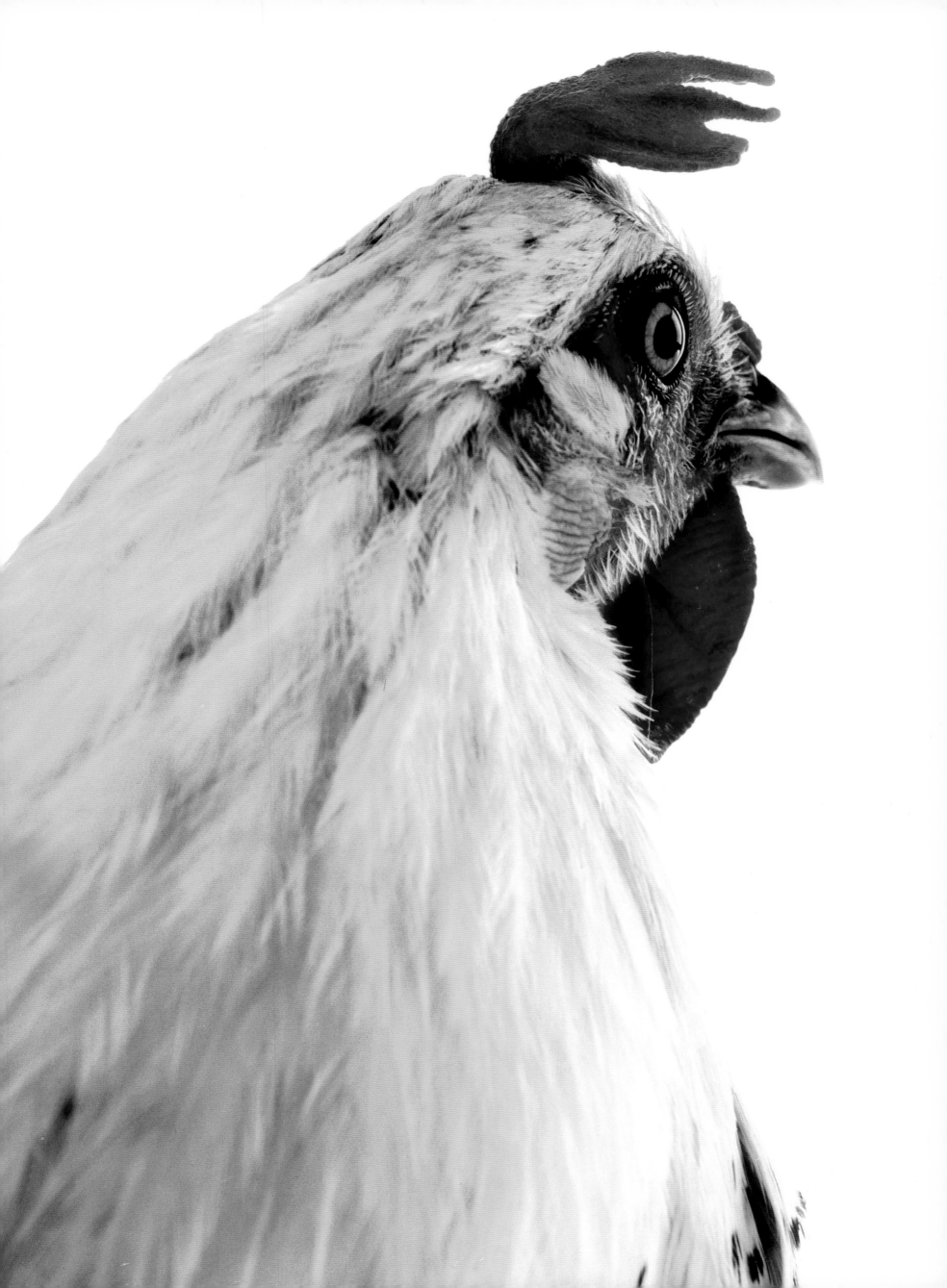

The rooster doesn't stand up unless
it is to get on his high horse. He can
barely be tamed, he eats out of your hand,
pecks at your palm, then turns around and
shits on your clog; the rooster isn't nasty,
he's dumb and thinks he's a king.

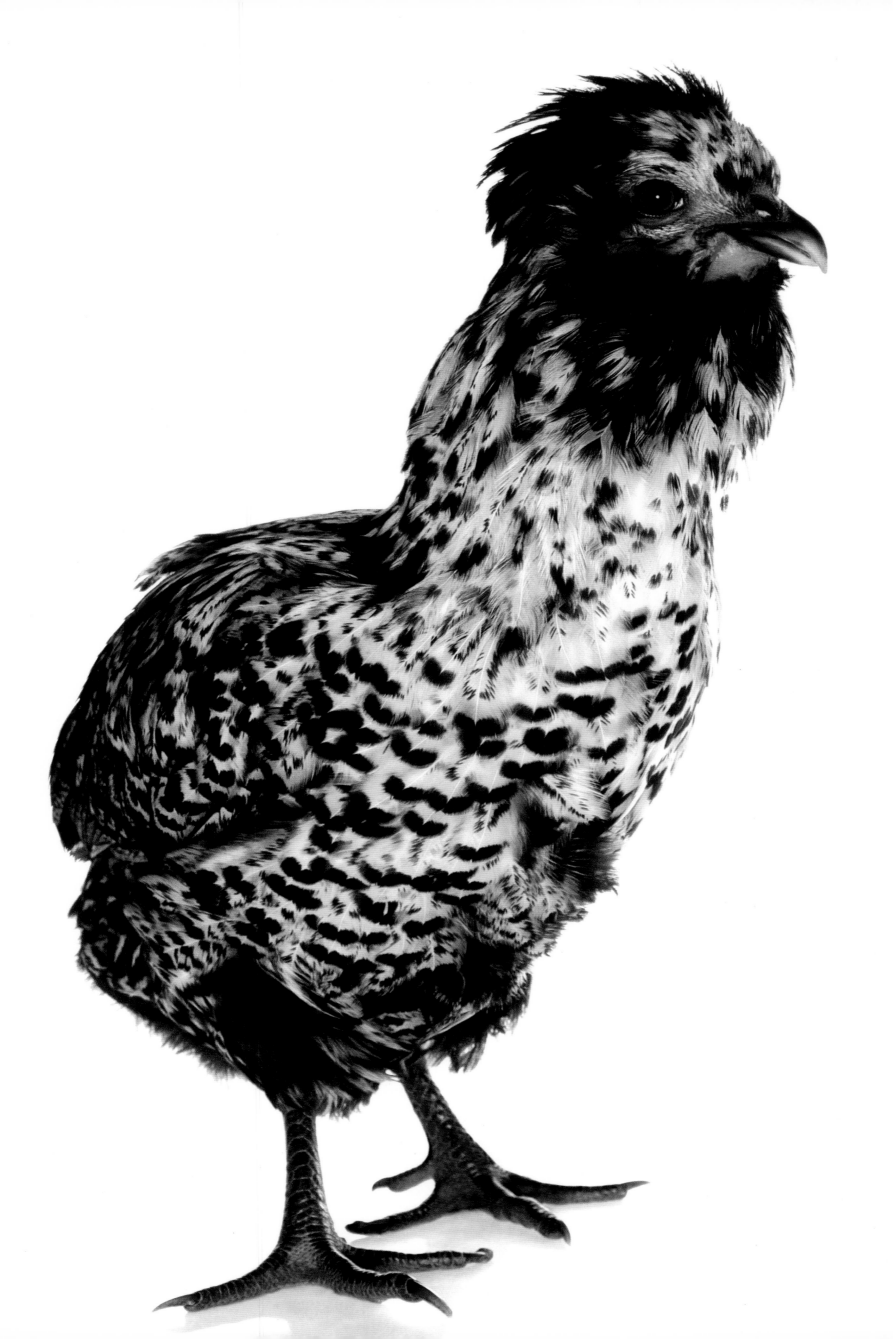

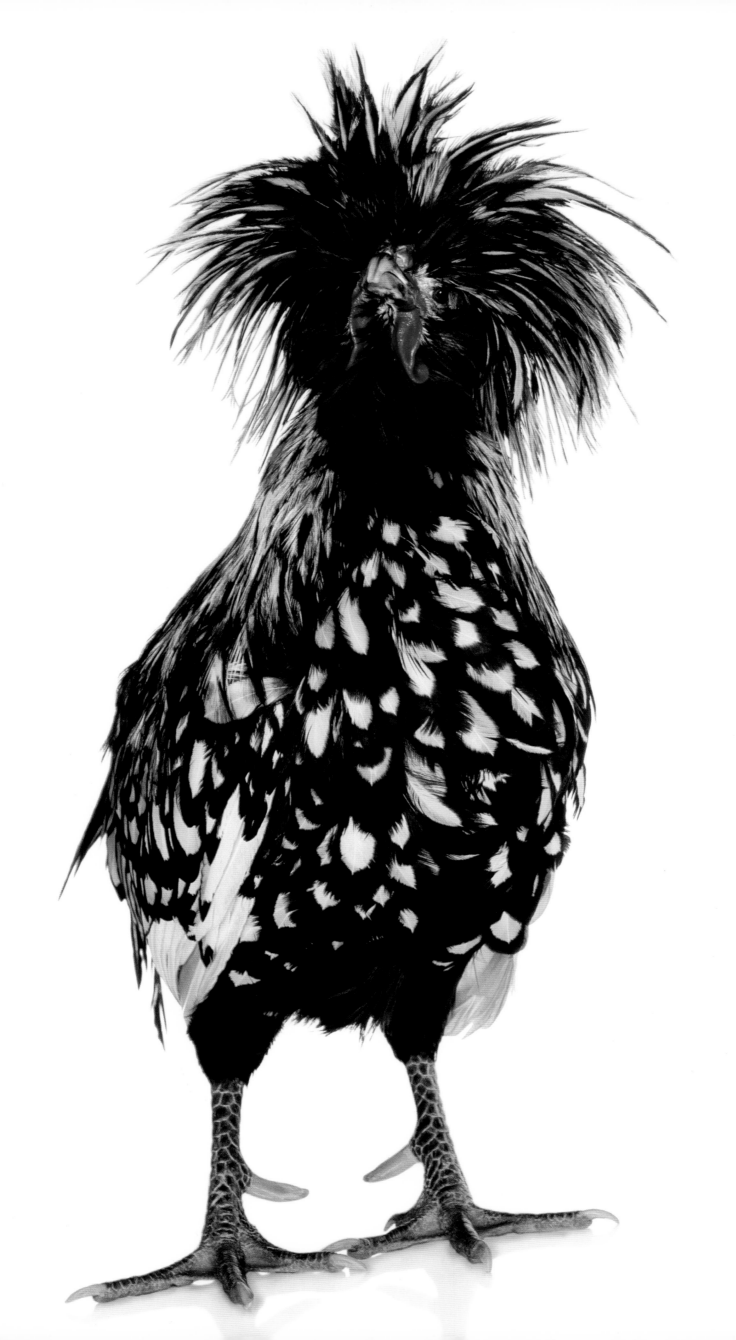

The planet of the roosters, whose existence is known only by a few idle specialists, is called Gallia, under the pretext that the Gallinaceae argue over its reign. It was discovered, roughly guessing (as it is invisible to the eye) at the end of the nineteenth century by an amateur Greek astronomer named Dimitri Kodossis who liked to rummage through the chaos of the universe. In France, Gallia is more often known as "Little Helen," in retaliation because, in Greek, Gallia means France and the rooster is her emblem, which is nothing to brag about (foreigners, especially the Belgians, claim that France didn't steal him, since he is presumably the only animal that sings with his two feet in the shit…)

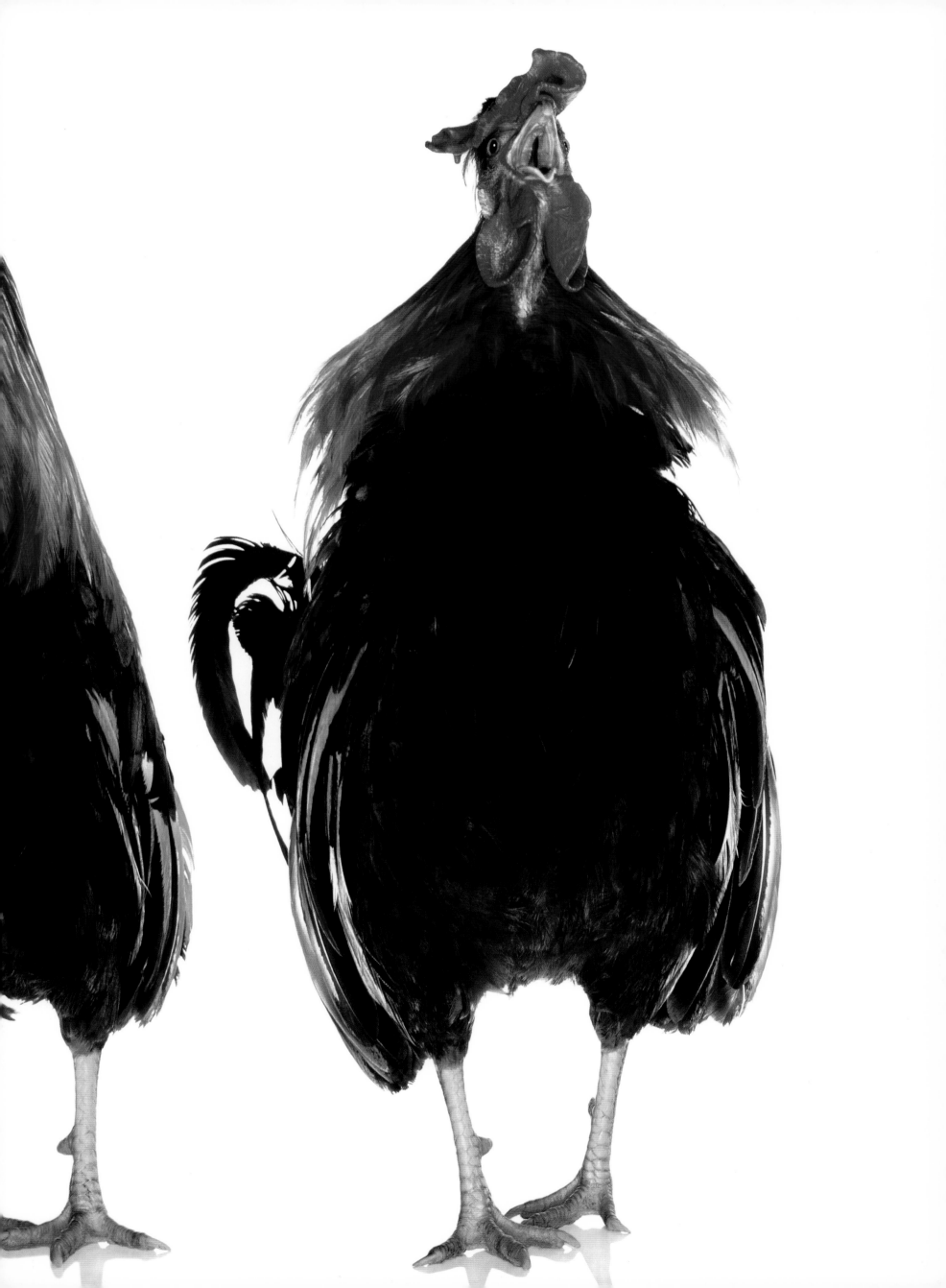

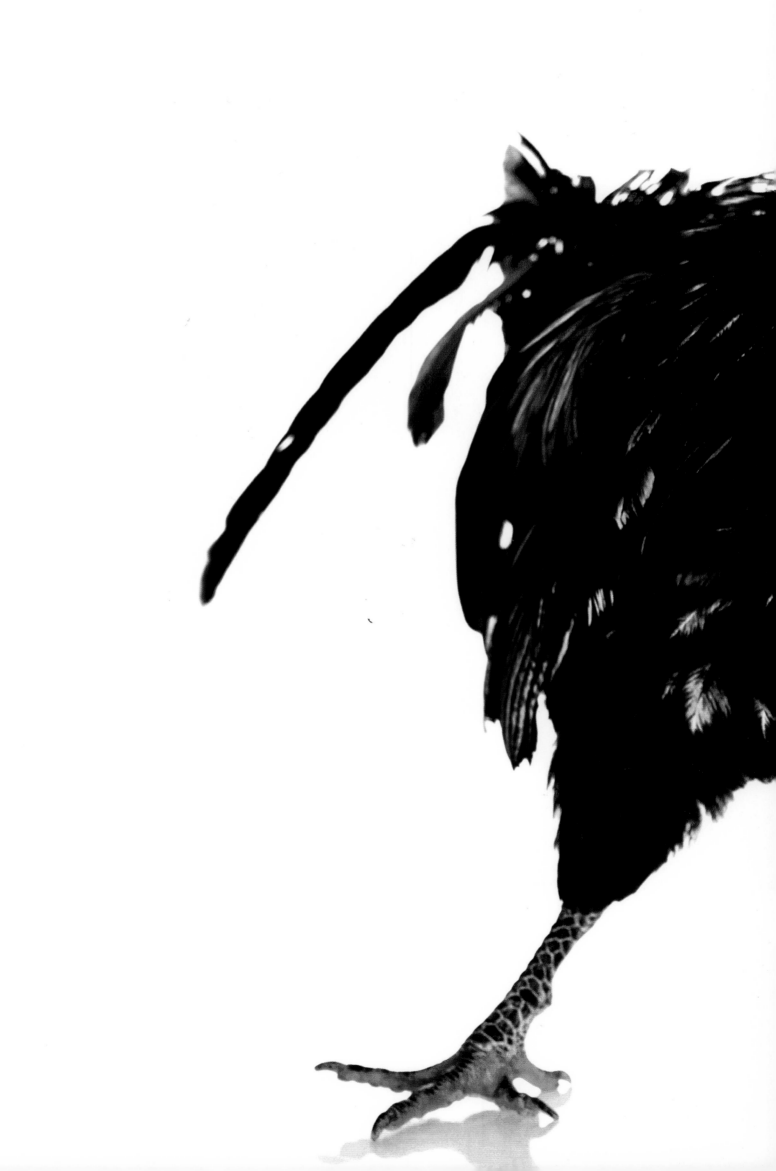

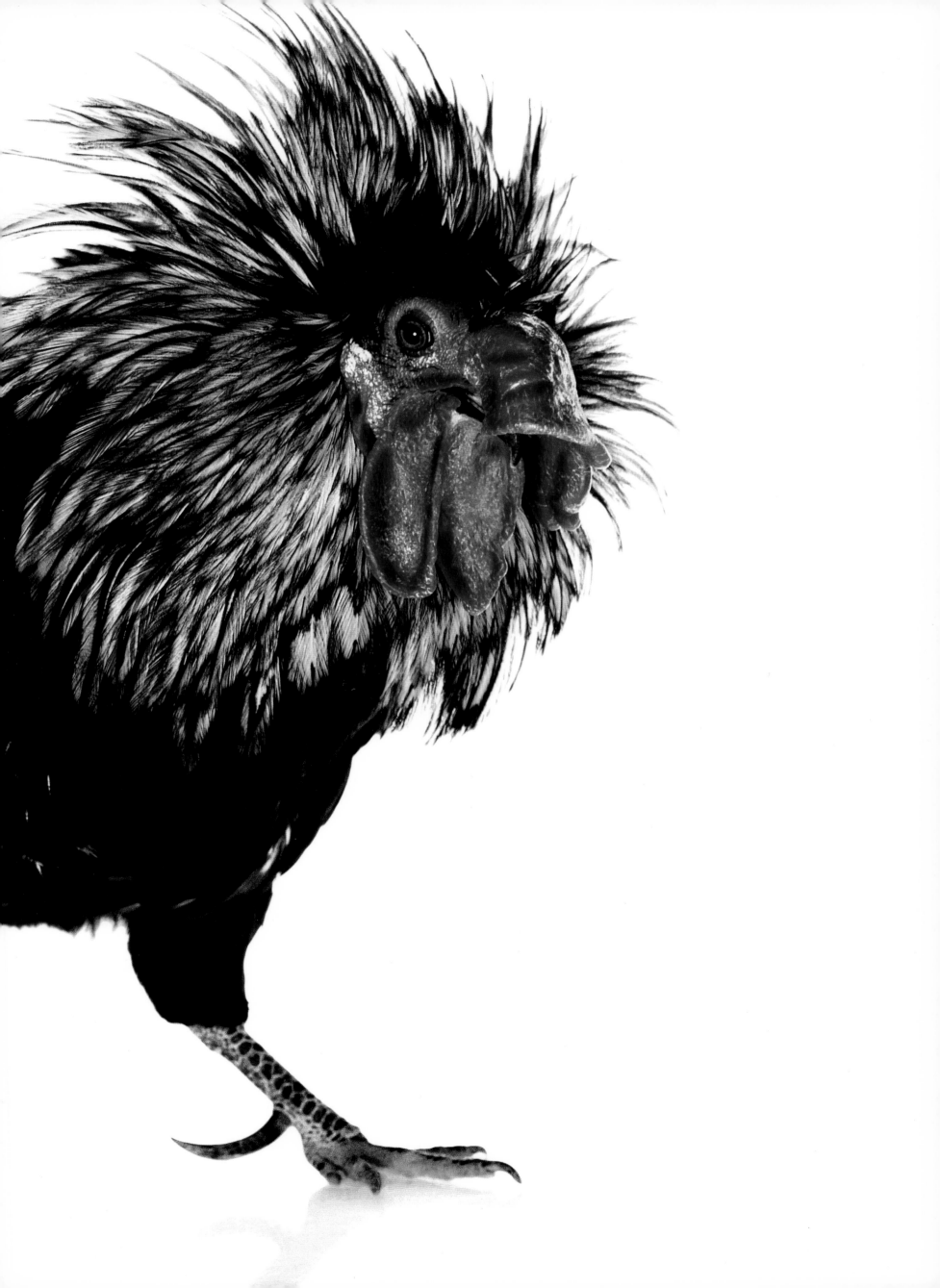

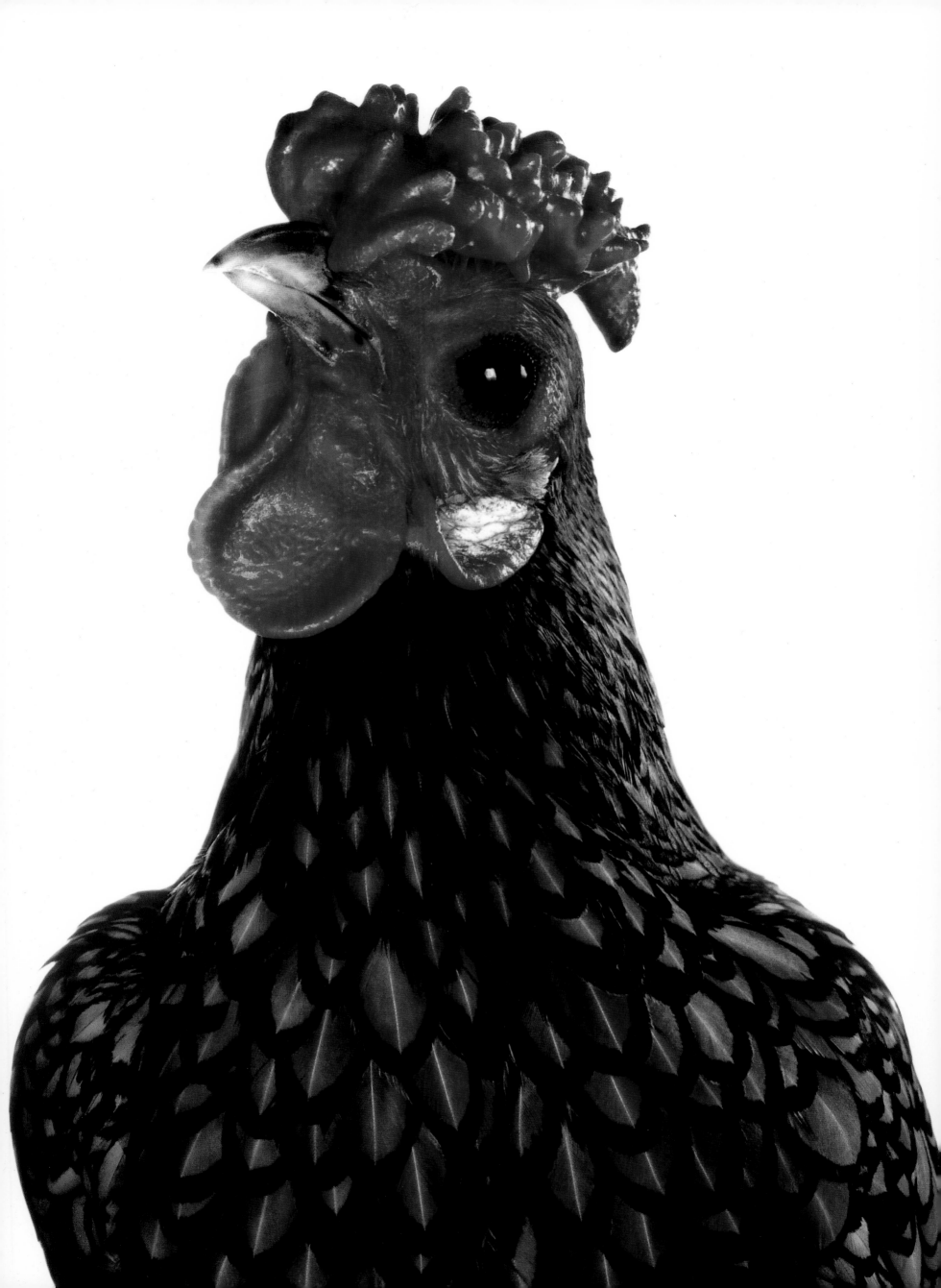

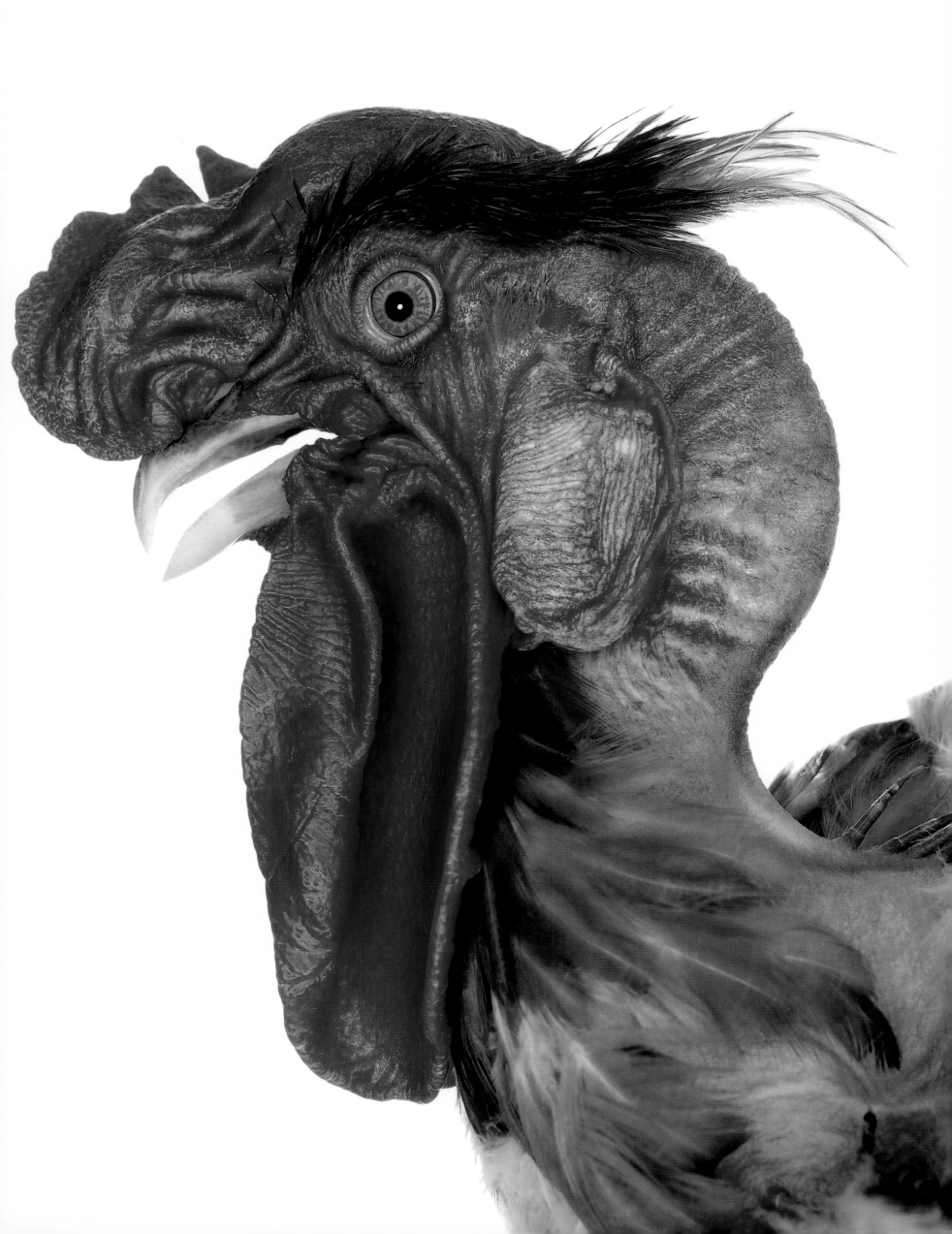

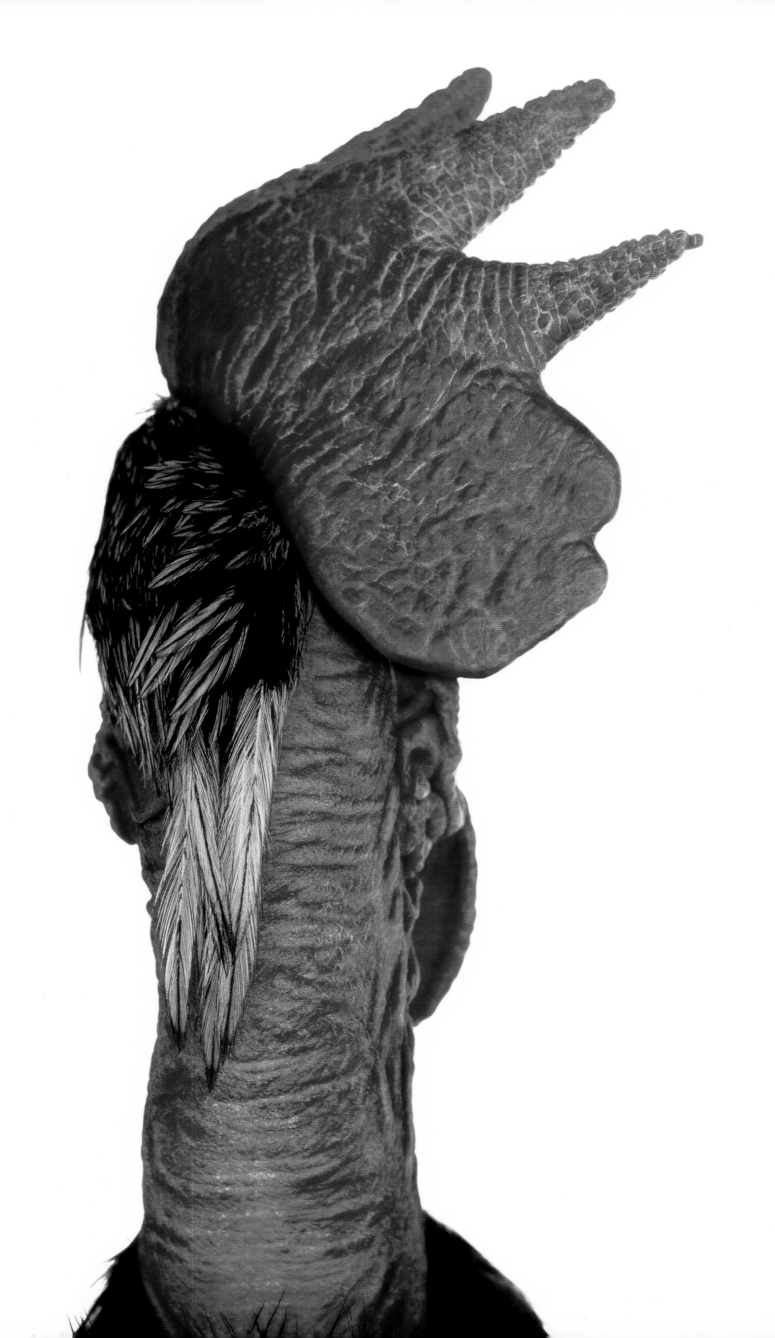

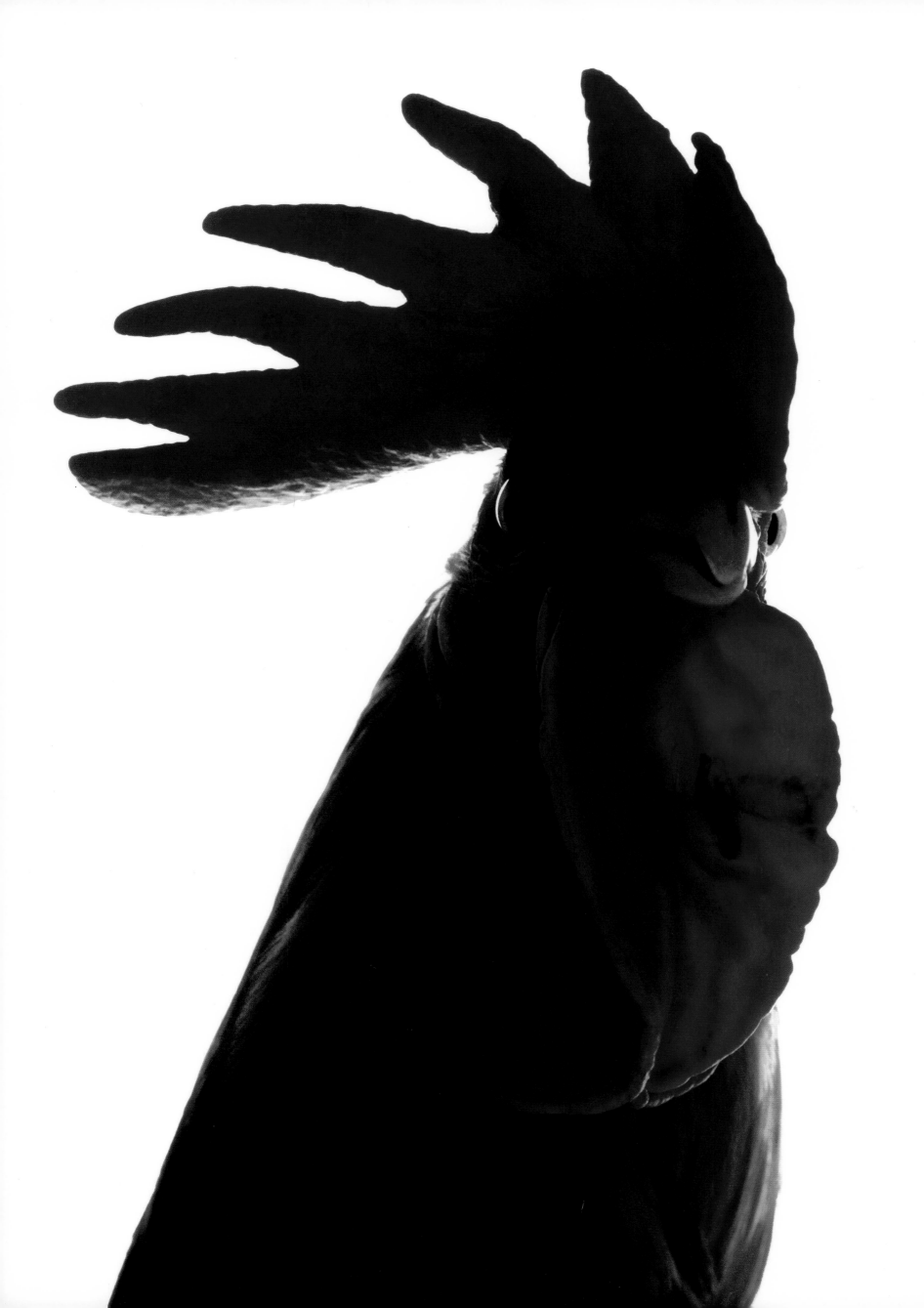

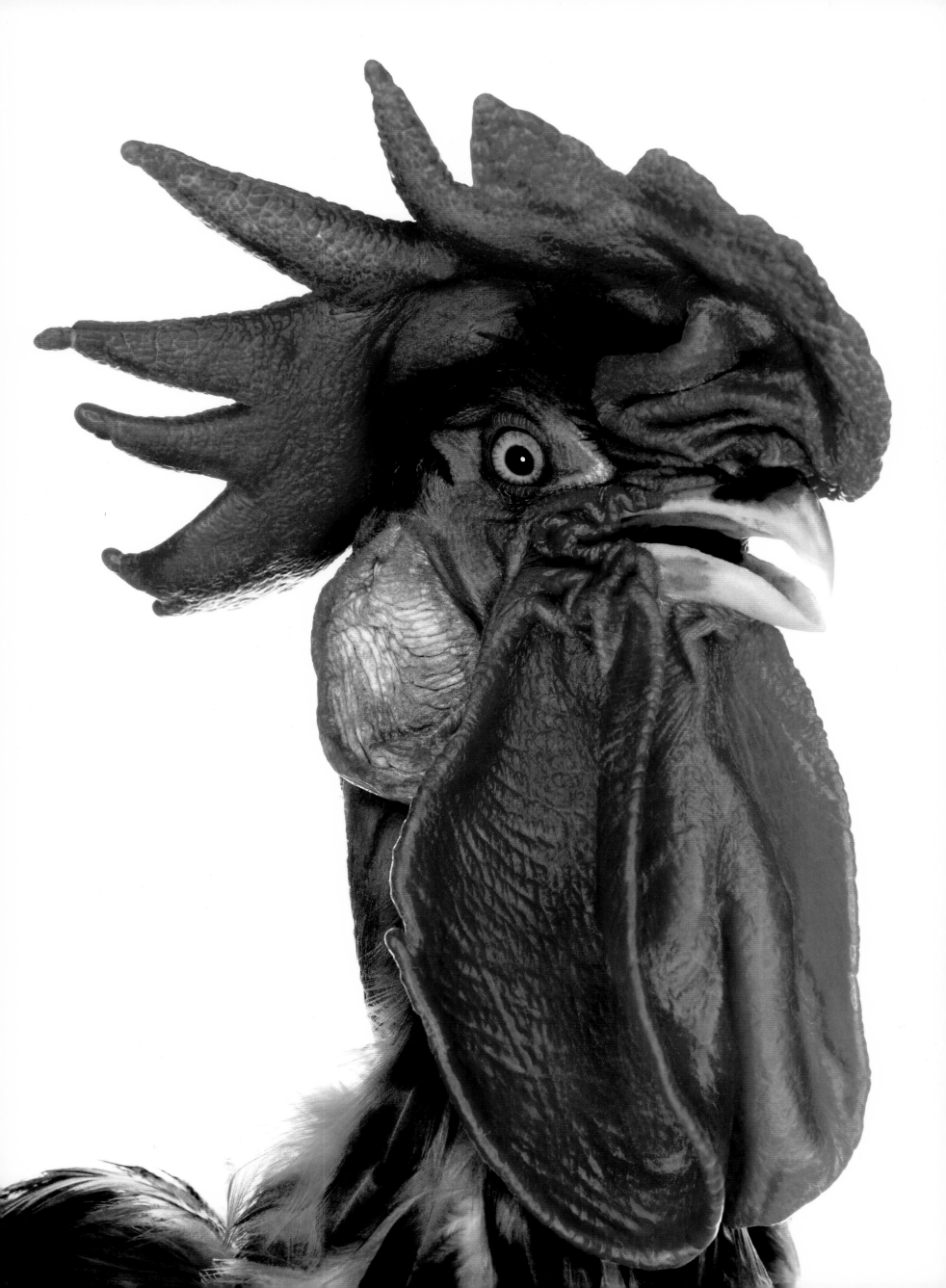

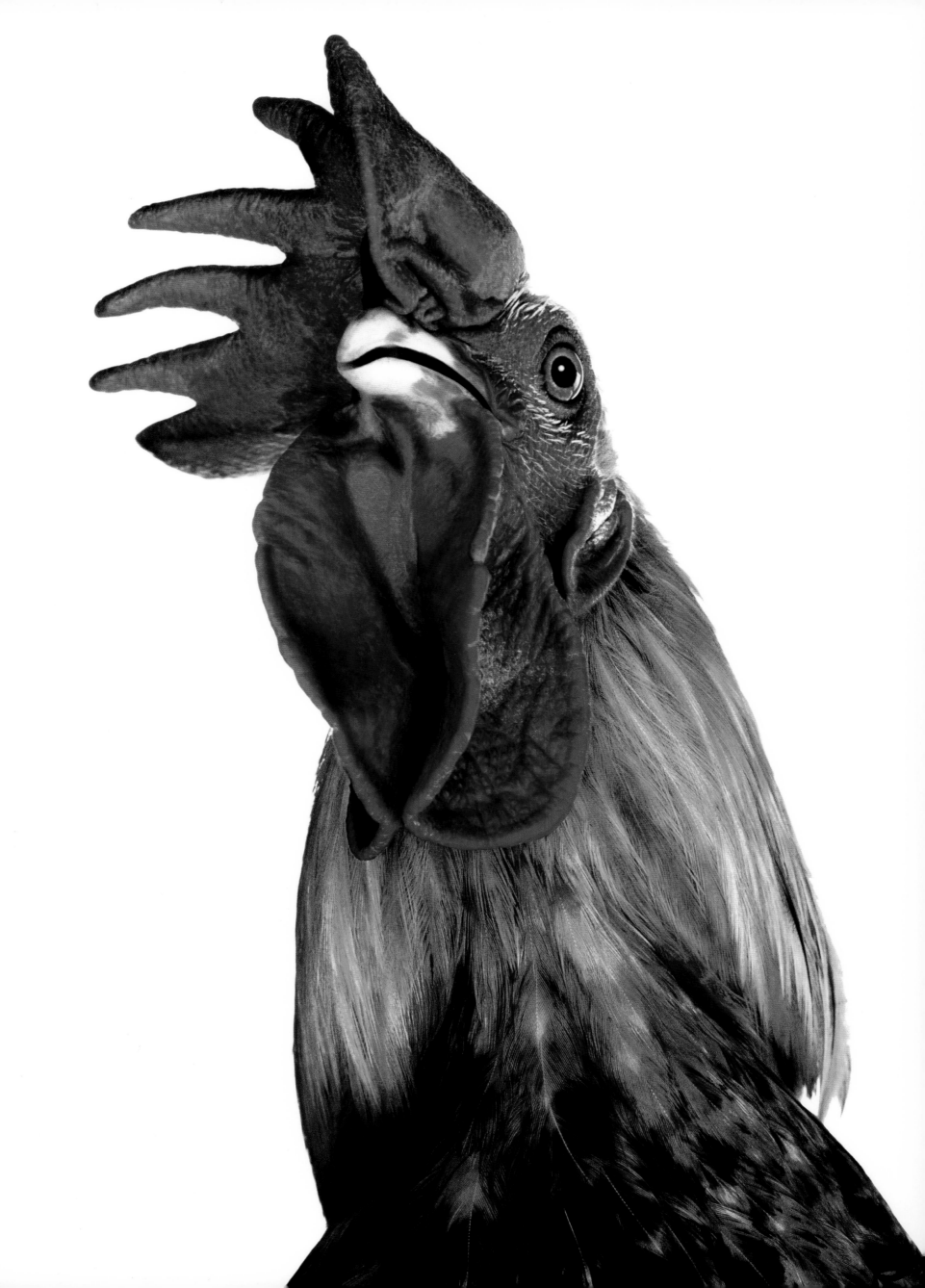

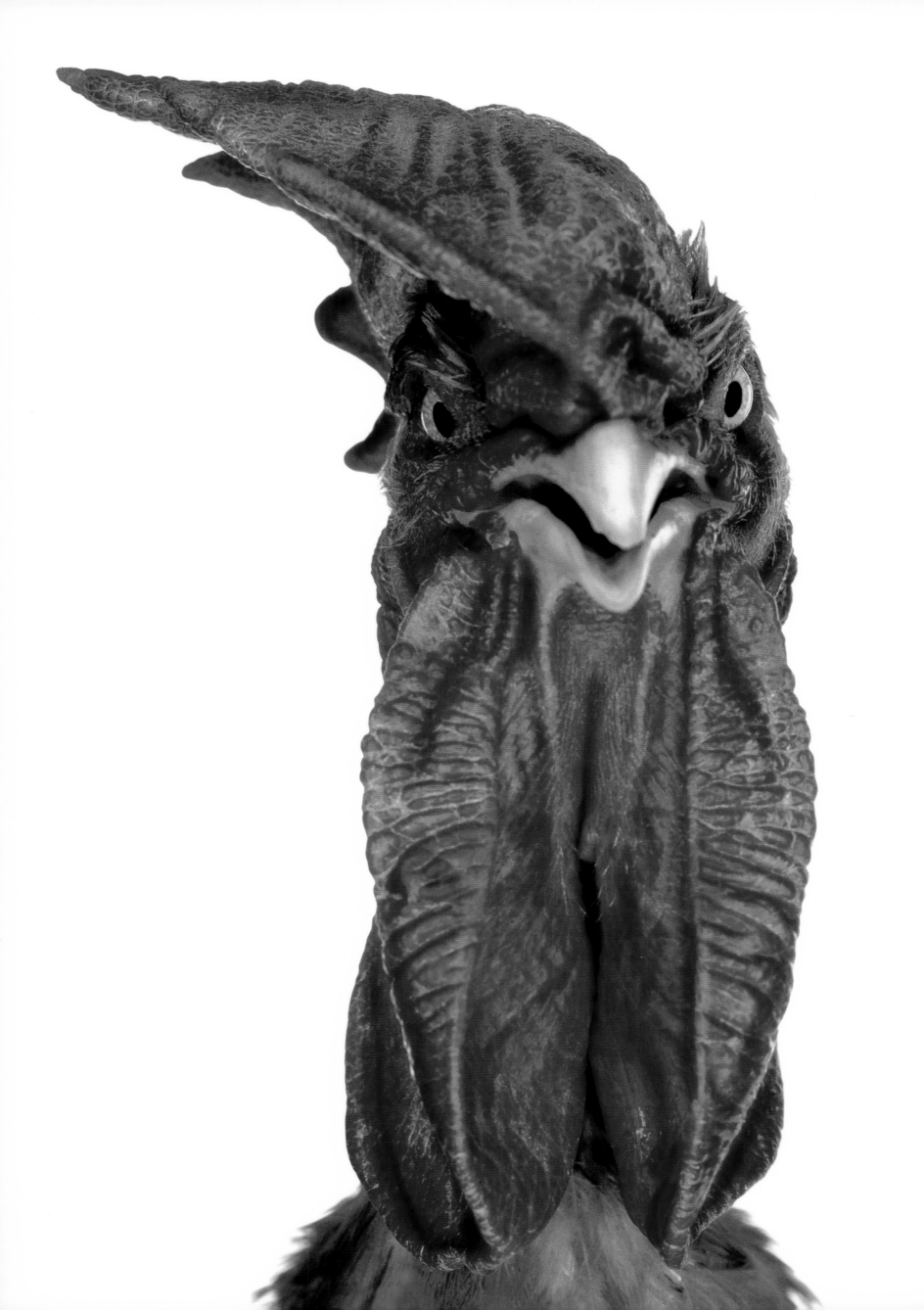

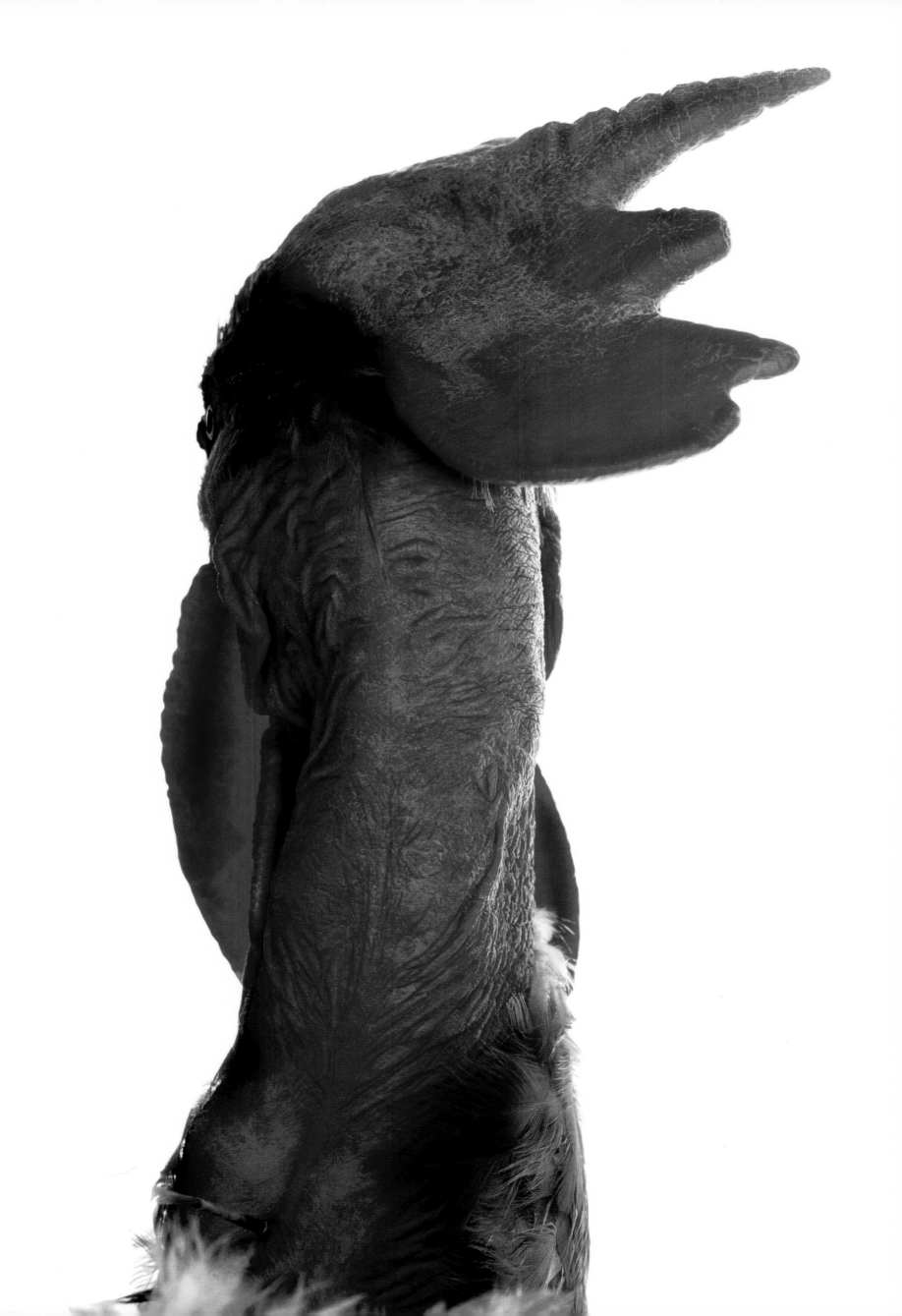

The rooster is sexually obsessed,
that's all there's to it. Neither perverse
nor lecherous, just a sexual animal.
The rooster rules over his harem
like a master, sure of his charm;
he hardly bothers with seduction, jumps
his females, plants his spurs in them and
then, without any further ado, his cock.
The rest of the time he sings,
and sometimes even during.

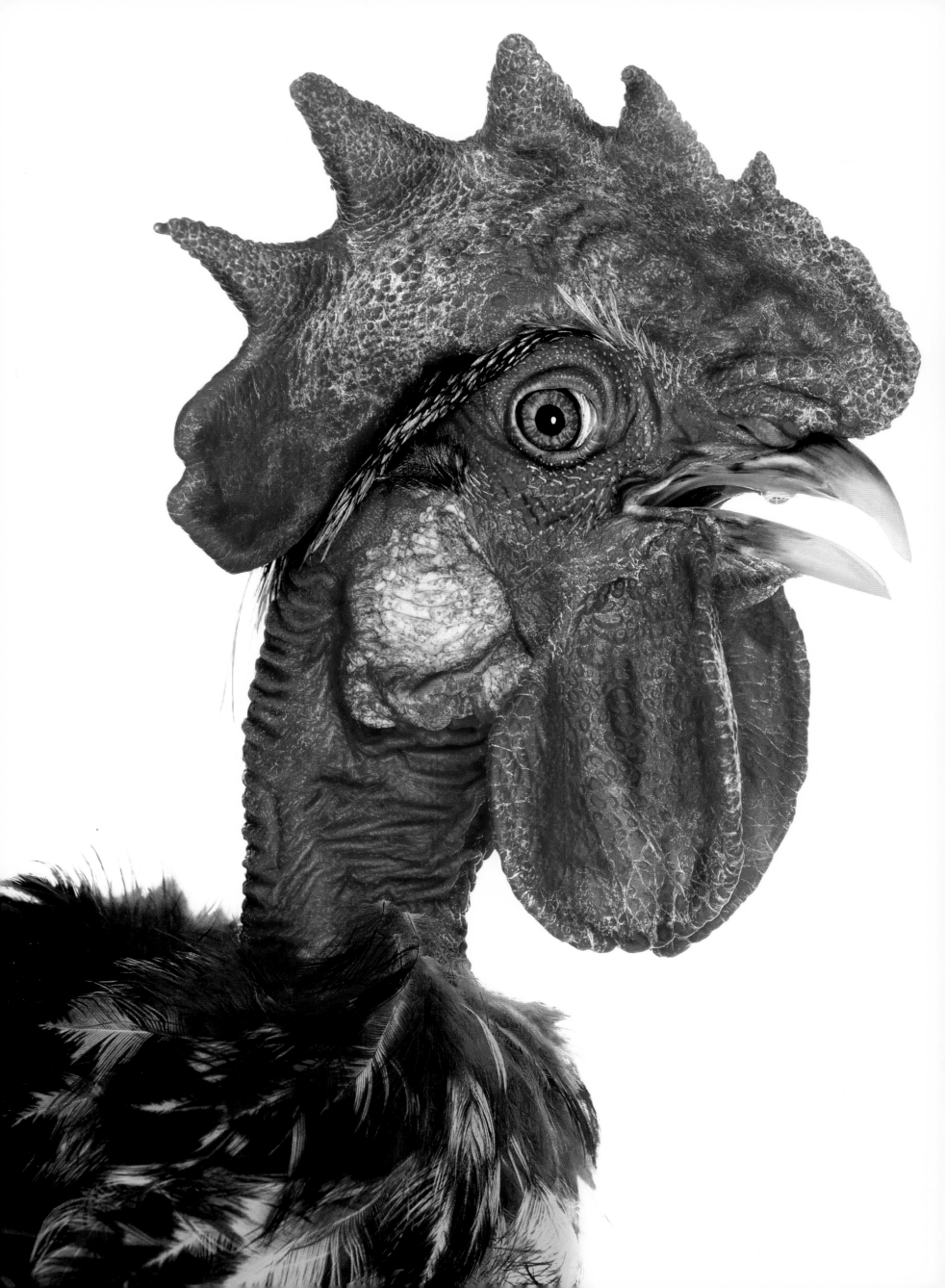

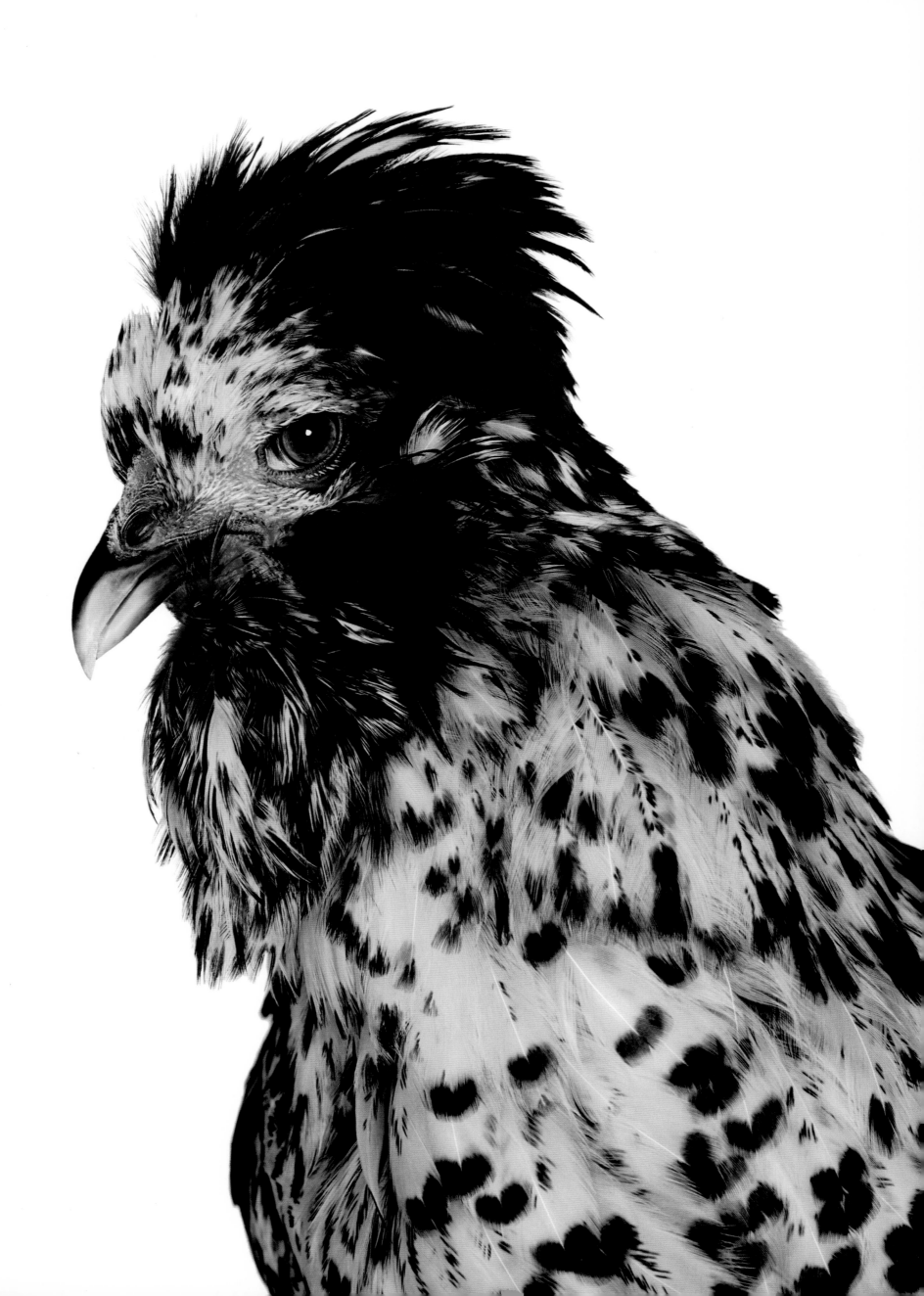

His multicolored plumage gives
him the look of a pearooster,
he removes the unwanted hair from
his spindly calves, his jay-like
tail arms, and hindquarters with
a bouquet of sickles. So marvelous,
he thinks, that we dare not call
man's most beautiful garment
after the rooster's tail but rather,
and more modestly, name it a tailcoat.

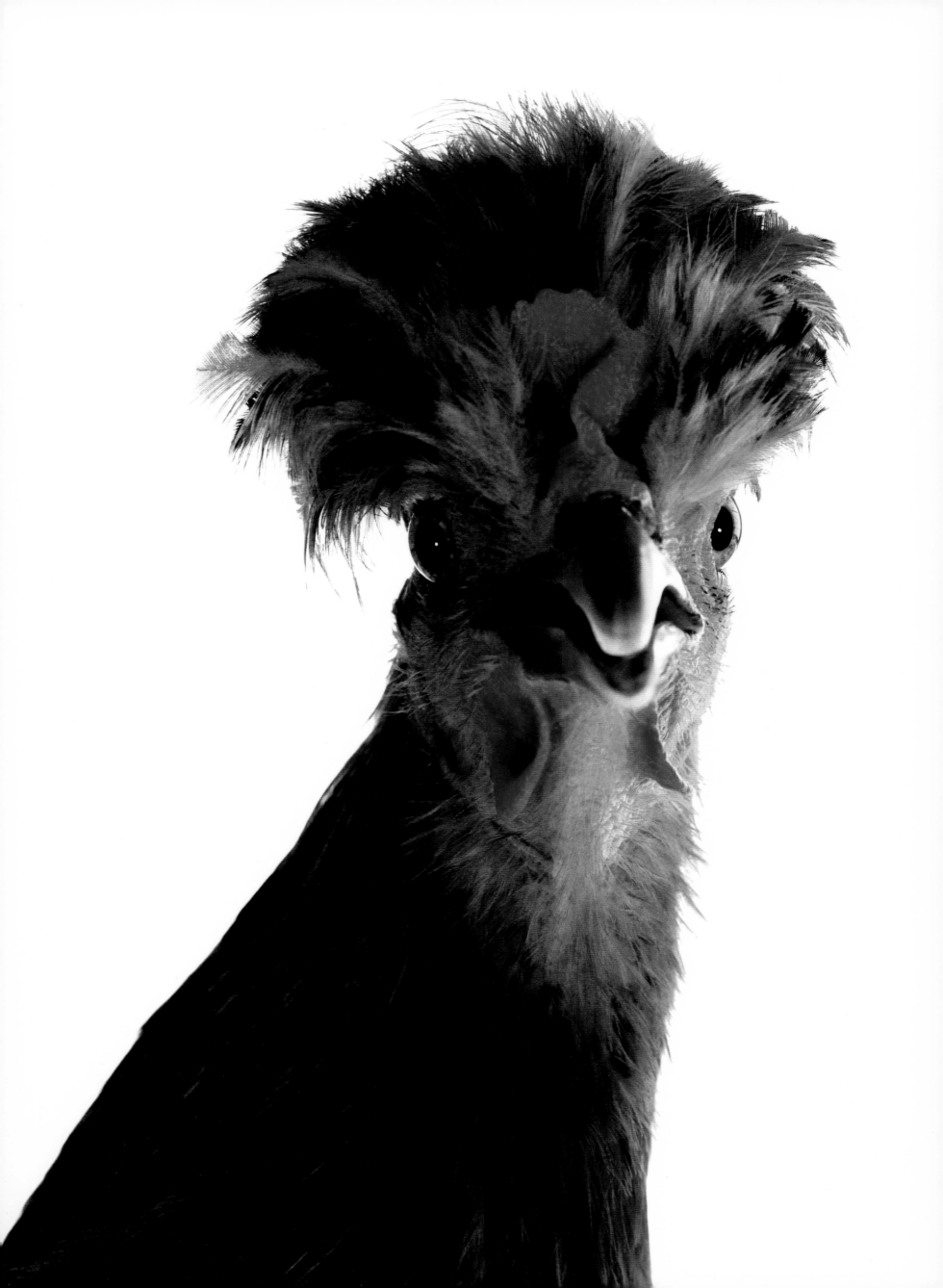

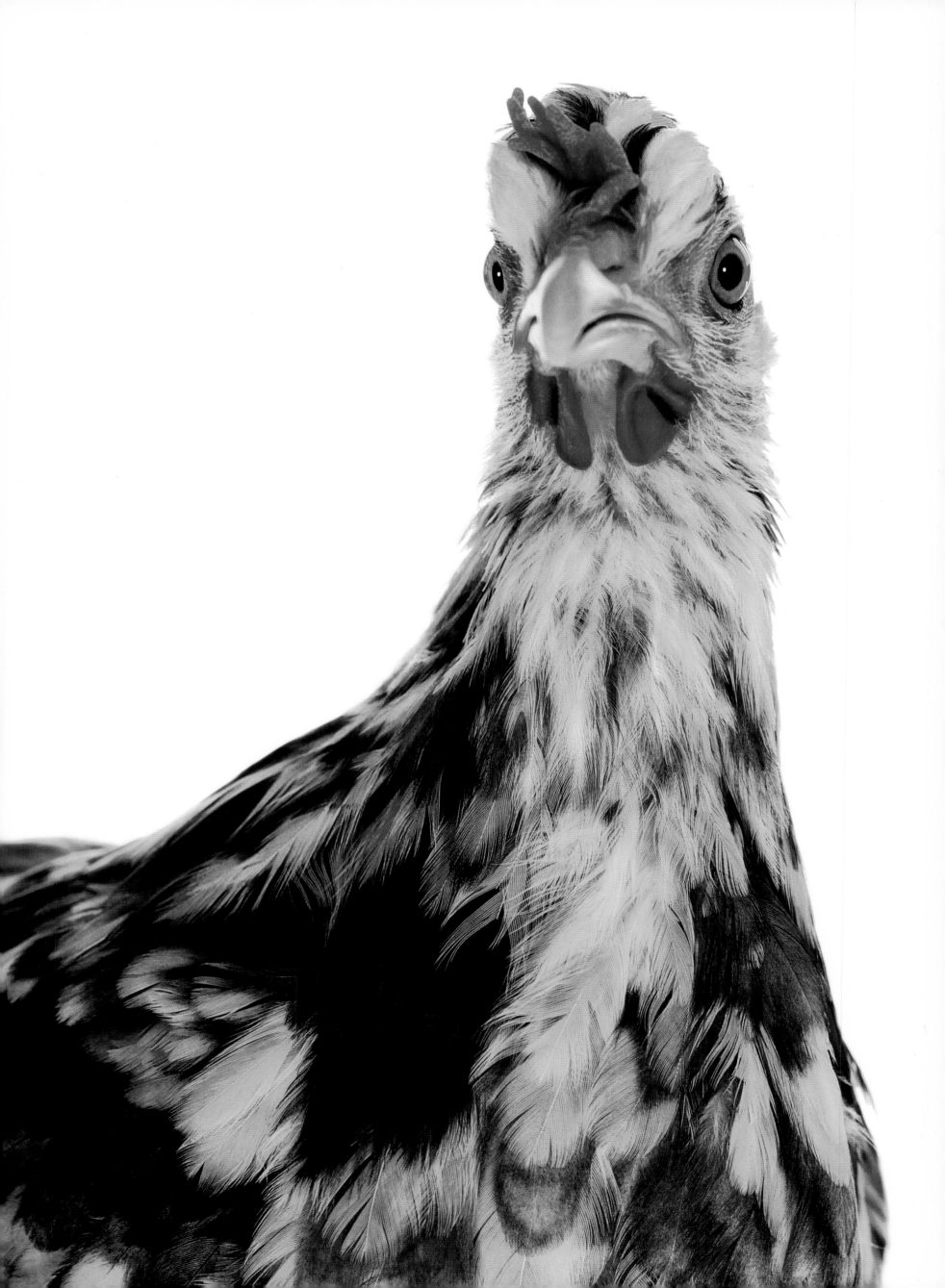

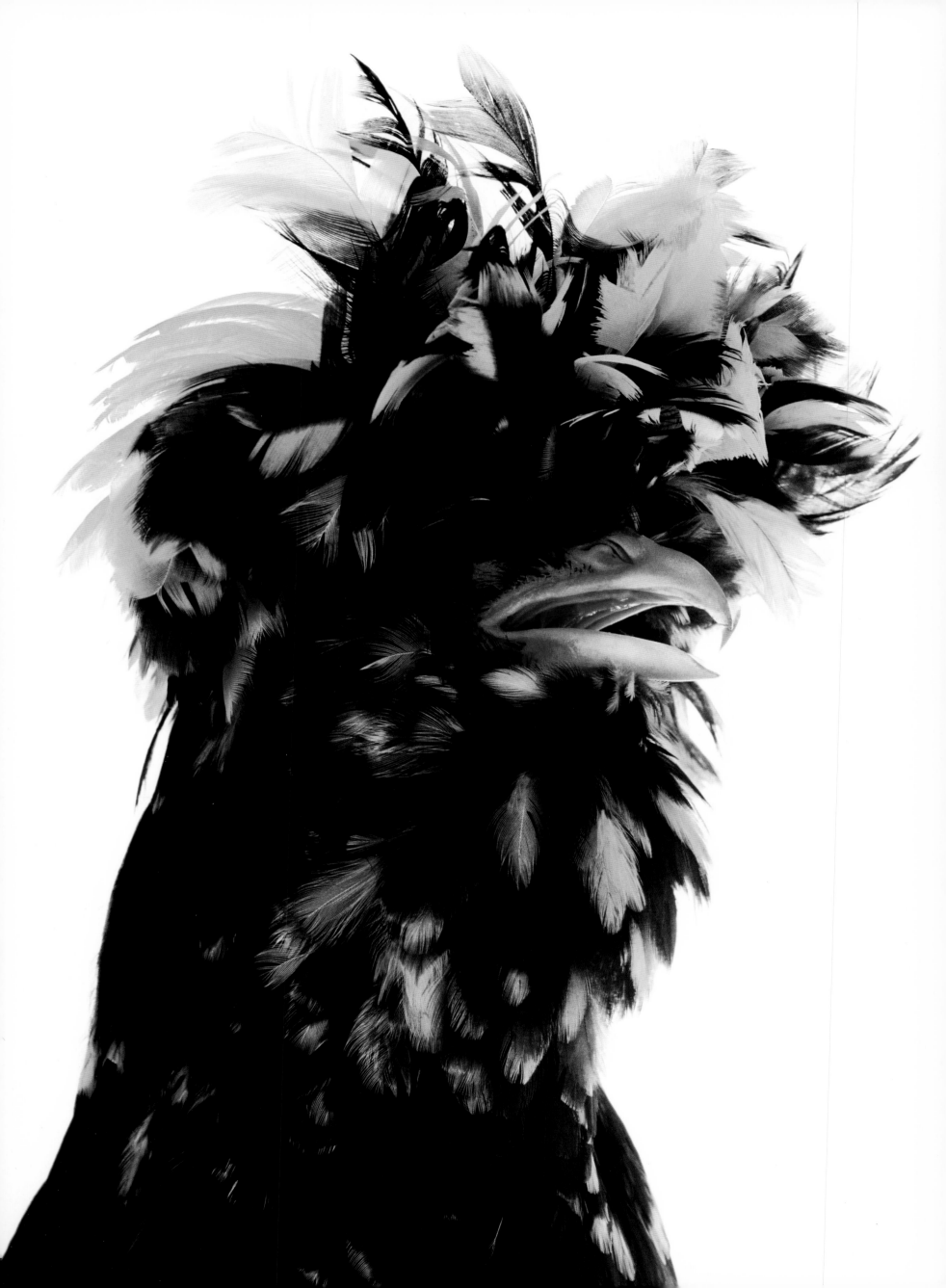

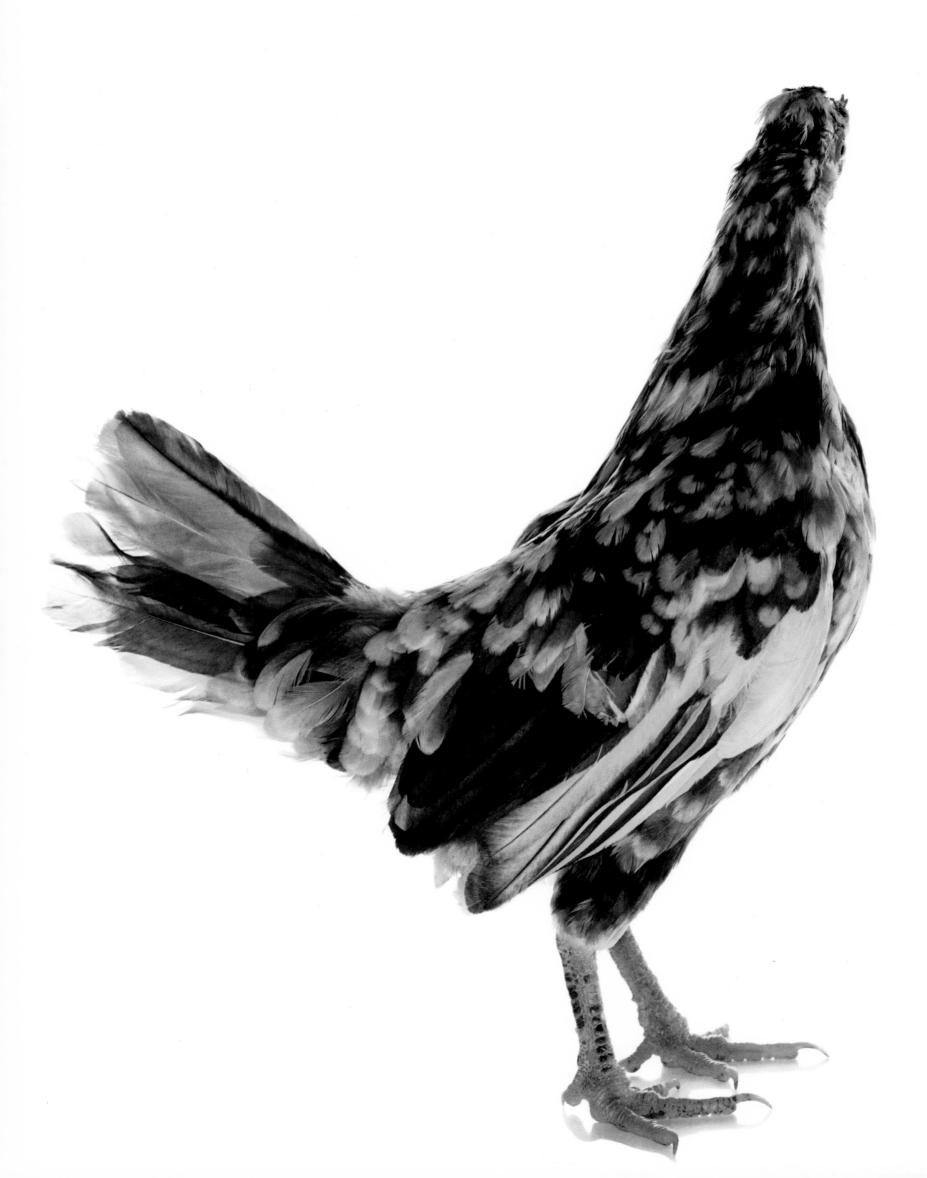

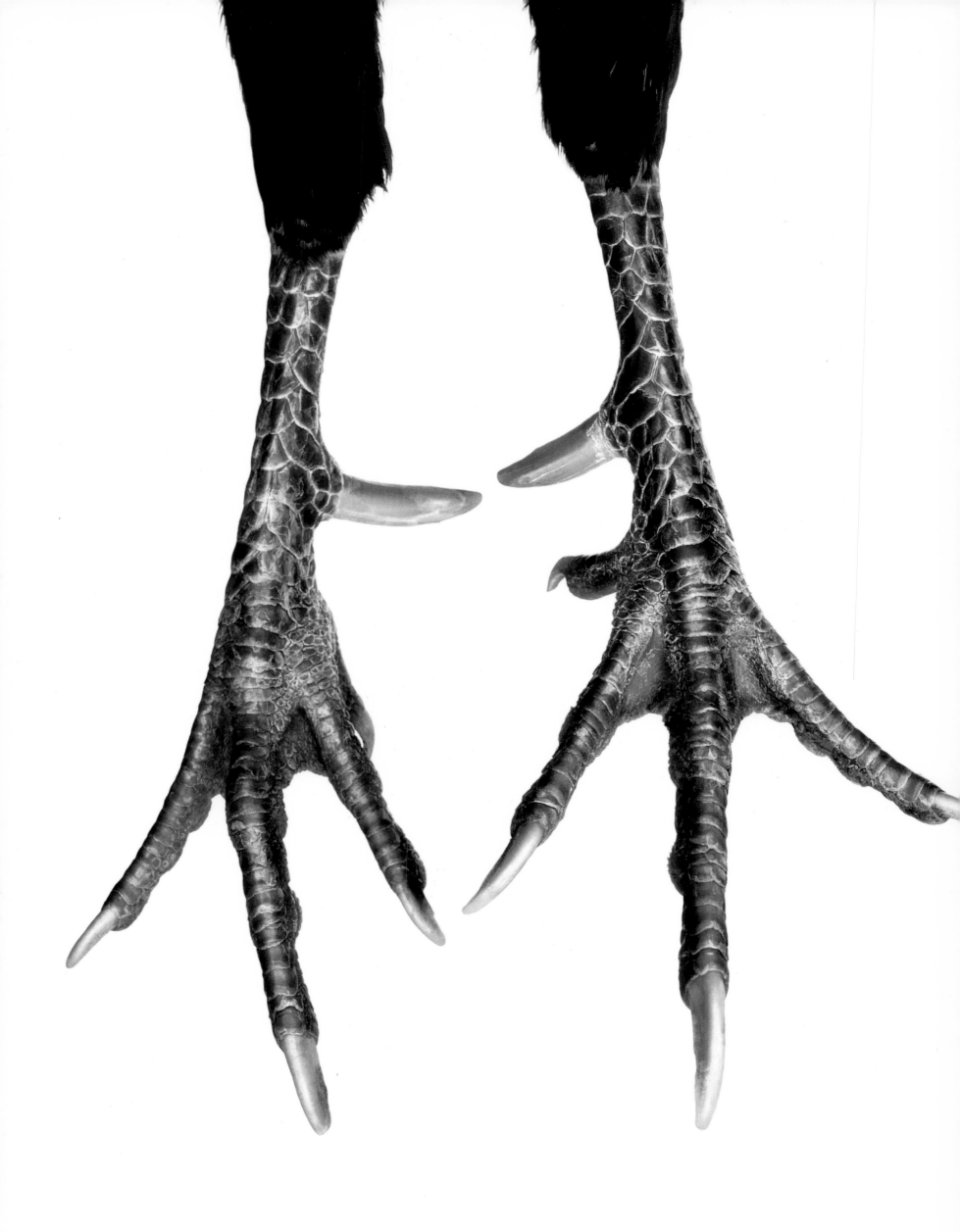

Acknowledgments

Philippe Schlienger would like to thanks Pierre Plé, collector and breeder, le Buisson, 61110, Bretoncelles
and the Artémise Gallery, Rémalard (France).

PHILIPPE SCHLIENGER lives and works in the Orne region of France. A pioneer in digital photography, he also has vast experience in advertising, architecture, and business. In addition to his commissioned work, he conducts researches on how to intervene into deeply familiar items to create magical images.

JEAN-BAPTISTE HARANG is a journalist for the French daily *Libération*, in which he published the feature, "Du Coq à l'âne", in 2003. Excerpts from the articles are reproduced as captions to the photographs in this book. He has published four novels to date, as well as a collection of portraits of novelists.